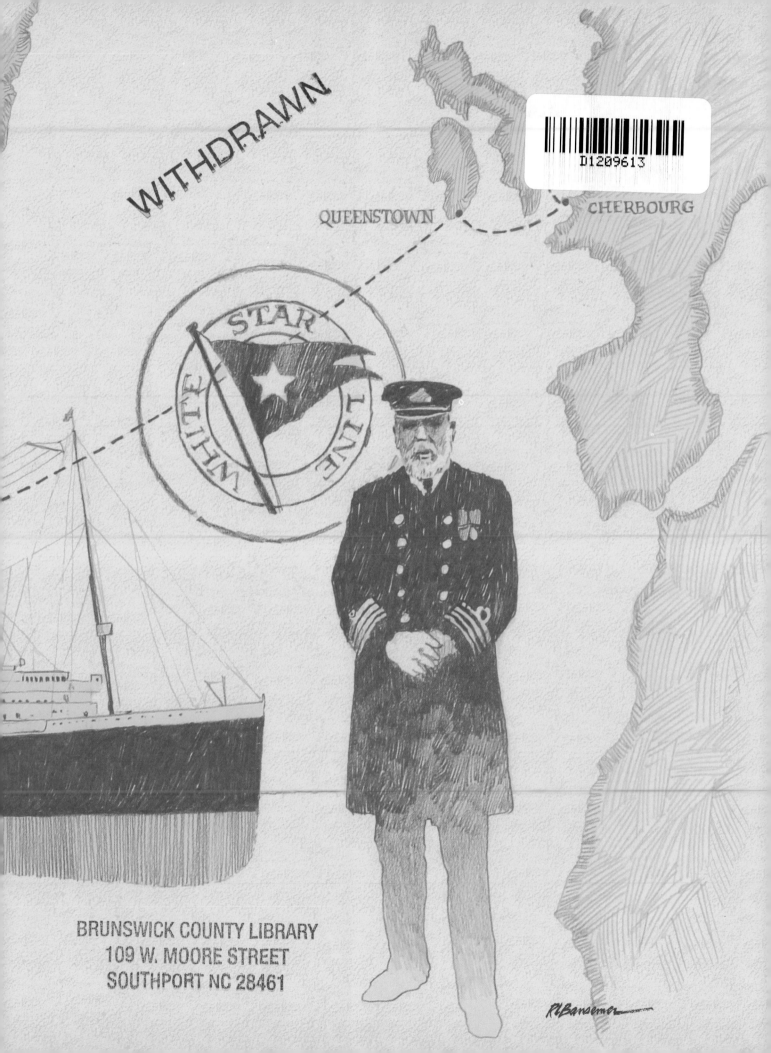

WITHDRAWN

QUEENSTOWN CHERBOURG

STAR
WHITE LINE

D1209613

RLBansemer

Journey to Titanic

Journey to Titanic

Roger Bansemer

 Pineapple Press, Inc.
Sarasota, Florida

Inquiries should be addressed to:

Pineapple Press, Inc.
P.O. Box 3889
Sarasota, Florida 34230

www.pineapplepress.com

Library of Congress Cataloging-in-Publication Data

Bansemer, Roger.
 Journey to Titanic / by Roger Bansemer.— 1st ed.
 p. cm.
 ISBN 1-56164-292-4 (alk. paper) — ISBN 1-56164-293-2 (pbk. : alk. paper)
 1. Titanic (Steamship) 2. Titanic (Steamship)—Pictorial works. 3. Shipwrecks—
North Atlantic Ocean. 4. Underwater exploration—North Atlantic Ocean. 5. Bansemer,
Roger—Travel—North Atlantic Ocean. I. Title.

G530.T6B496 2003
910'.9163'4—dc21 2003056477

First Edition
10 9 8 7 6 5 4 3 2 1

Design by Roger Bansemer
Printed in China

Photograph credits

p. 23 Lowell Lytle
p. 43 Roger Bansemer
p. 50 Lowell Lytle
p. 53 Roger Bansemer
p. 63 Roger Bansemer
p. 66–67 Roger Bansemer
p. 73 collection of Ralph White
p. 76 and cover painting done by
 Roger Bansemer from photo
 supplied by Tim Friend
p. 82 collection of Ralph White
p. 83 collection of Ralph White
p. 93 collection of Ralph White

p. 96 collection of the Library of Congress,
 Prints and Photographs Division
p. 105 collection of Ralph White
p. 108 collection of Ralph White
p. 111 Roger Bansemer
p. 112 Roger Bansemer
p. 113 Lowell Lytle
p. 120 Lowell Lytle
p. 121 top, Roger Bansemer;
 bottom, collection of Ralph White
p. 122 Lowell Lytle
p. 123 Roger Bansemer

It seems appropriate to dedicate this book to the people who lost their lives on the *Titanic*, and I do so with their memory in mind. But my most heartfelt dedication goes to those people in my life who have meant the most to me, my family: my wife, Sarah, my daughters, Lauren and Rachael, and my mom and dad.

Acknowledgments

Special thanks go to my friend Lowell Lytle for opening up the door for me, and to G. Michael Harris for inviting me to be a part of the expedition.

A special thanks to Ralph White, with whom I dove. The hours and hours of time Ralph spent answering questions and the knowledge he so selflessly shared gave me an added appreciation of the *Titanic* and the feat of diving it.

I'd also like to remember Anatoly Sagalevitch and all the people on the Russian research ship *Keldysh* who made my stay so pleasant.

Thanks also to Howard Howell; Mark Lach; Lloyd Sowers; Tim Friend; Andreas B. Rechnitzer, Ph.D.; and Jim Sinclair.

Foreword by James Cameron

Academy Award–winning director of *Titanic*
and *Ghosts of the Abyss*

It was the tradition, in the days before photography was invented, for the great expeditions of the Age of Exploration to take with them an artist to chronicle their journey and the things they found. The images created by these brave artists, of strange animals and exotic plants, of the crumbling ruins of mysterious lost civilizations, and of the bizarre tribal regalia of the indigenous peoples who were encountered, brought to life the tale of the journey when the explorers returned to their home ports. Thus, amazed Europeans first saw giraffes and elephants, the pyramids of the Maya, and the sequoias of California.

Roger Bansemer revives that time-honored tradition with his visual chronicle of an expedition to *Titanic*. With the enthralled eye of a newcomer, he takes the reader through the entire experience of the voyage, with special attention paid to his dive to the wreck.

Titanic has passed from history into legend, and from our world into the underworld. It lies two and half miles below the surface of the North Atlantic, which is about as remote and inhospitable a place a person can visit. To visualize this, imagine you are in a jetliner at 12,500 feet altitude, and you look down at an 800-foot ship on the sea below. It will appear to be a tiny sliver. If you could strip away the water, this is how *Titanic* would appear below you as seen from your ship at the surface. And this is the distance you will descend when you make a dive to the wreck.

In eternal blackness, where no sunlight has ever penetrated since the world began, and in crushing pressure created by the millions of tons of seawater above her, the *Titanic* stands above the seafloor like some ancient ruin. The once-mighty reciprocating steam engines tower four stories tall and look, as my friend Bill Paxton said when he saw them through the port of the *Mir* submersible, like "twin sphinxes guarding a forbidden tomb." It is an eerie, silent place, a place of mystery and tragedy. It is a tomb, in a very literal sense, but also a monument to human folly and the limits of technology. And yet we celebrate our engineering and technology every time we descend to those depths, entrusting our lives to our inner-space craft.

Having made two expeditions to the *Titanic* site myself, and twenty-four dives to the wreck, I found Roger Bansemer's narrative and accompanying images to be comfortably familiar. The Russian *Mir* pilots and scientists are my friends, with whom I have made four voyages of exploration. As I sit writing this in a hotel room near the docks of Port Everglades, Florida, I am about to embark on my fifth deep-ocean expedition, again with my Russian colleagues. The research vessel *Akademik Keldysh* is my second home, and Roger has captured life aboard her perfectly. All the usual suspects are accurately represented: Anatoly Sagalevich, the creator of the submersibles and the driving force behind the Russian deep submergence program; Genya Chenayev, sub pilot extraordinaire; Ralph White, the adventurer who's seen and done it all; and all the others aboard who labor and sacrifice to keep the dream of deep ocean exploration alive.

Roger's images and words will allow the readers to feel as if they have been on the voyage themselves, spent time with these people, and made the ultimate deep dive to the grave of the great liner herself. No one who sees the wreck of *Titanic* leaves that place unchanged, and this book conveys that experience beautifully.

—James Cameron

How did this happen?

Titanic. There isn't a person on earth who doesn't know the story. Since it sank on the night of April 14, 1912, taking 1523 lives with it, the fascination with the ship and its story just seems to grow. Of the tens of thousands of ships that have sailed the seas, the *Titanic* remains the most famous in the world. Hundreds of books and countless articles have been written about it, yet few people have actually laid eyes on its hull sitting quietly on the ocean floor two and a half miles down in what can only be described as absolute darkness and total silence. It's a place that few people have ever visited, and those who have seen it are changed for the rest of their lives.

On August 18, 2000, I was the 112th person to see the *Titanic* since it sank. This book is a journal with my impressions, thoughts, and observations about the ship and my visit to it—not as a historian or scientist but as an artist who experienced a journey to *Titanic* in the most basic, visual sense.

The people who are privileged to see the *Titanic* on these rare expeditions to retrieve artifacts in dives that last for twelve hours and more are primarily scientists, technicians, historians, and filmmakers. They are familiar with the ship and knowledgeable about most aspects of its construction and history—the kinds of people who can tell you how many rivets were used in the hull.

I was an exception. I knew nothing more than what I'd seen in the movie and television documentaries. Like most people, I had a natural fascination with the subject, but not to the degree I wanted to pursue it further. Unless you are prone to take up *Titanic* as a hobby, as many do, then the subject gets set aside by other interests and daily life— only to be sparked now and again by exhibitions, movies, and the like. That all changed one morning just ten days before I would actually be over the wreck site. Here is how it began.

A large, stout man by the name of Lowell Lytle dropped by my house for a visit as he often does. He has been a good friend of mine and my family since I was a small boy. Very creative and talented and looking much like Captain E. J. Smith of the *Titanic*, Lowell often plays the part in full uniform at openings of *Titanic* exhibitions around the country.

After saying hello he sank into a chair, but I could tell his enthusiasm level was high. His large hands opened and with a grand gesture he announced he had been invited as a guest to dive to the *Titanic*. The salvage company that helped to supply artifacts for *Titanic* exhibitions thought it would be helpful in Lowell's performances to actually experience a dive. I sat there in envy and amazement. Just to know someone about to dive to the *Titanic* was sort of like meeting an astronaut.

I had just finished a new book about Carolina and Georgia lighthouses and had handed Lowell a copy for him to look at when he keenly suggested *Titanic* as a topic for my next book. My reply was that it would be great except I knew nothing about *Titanic,* and seeing the movie three times—something I rarely do—didn't exactly qualify me as a *Titanic* expert.

Besides, everyone I meet tells me I should do a book on something. Doesn't matter what it is. I can be walking my dog at the park and someone will suggest I do a book on dogs in parks. So I wasn't surprised at Lowell's suggestion.

The idea of doing a book about *Titanic* sounded good, but I wasn't the one with the invitation so the suggestion fell on my ears like all the rest. As Lowell left my studio, I gave him a copy of my lighthouse book. He told me he would show it to those in charge of the expedition and talk to them about the possibility of my going on the dive. Fat chance, I thought to myself. But it did stir my imagination for the rest of the morning.

With book in hand he drove off to meet with then–vice president and chief operations officer of RMS Titanic, Inc., Mike Harris. My book apparently stirred his imagination because that afternoon, at about three o'clock, the phone rang and Lowell was on the other end. "You're invited to go on the expedition" were the words that echoed in my ear.

Had Lowell not thought to drop by that morning or had I not been here when he did, things would have been quite different in my life. Bringing my book to show the expedition leaders opened the way for him to suggest they consider bringing an artist along. I happened to be in the right place at the right time.

After Lowell's convincing pitch, Mr. Harris agreed they had enough scientists and technicians on the expedition and it needed an "artist and a poet" for another view of things. For the rest of the day I was in shock and disbelief. I was just given a first-class ticket to the *Titanic* and had ten days in which to ready myself both mentally and with supplies.

It took days for the reality to sink into my brain: I would be visiting the most famous ship in the world. While I was trying to sort it all out, a mandatory medical exam was first on my to-do list. I also had to gather up things I would need to bring along—clothes, cameras, canvas, and paints. The mental preparation was a great joy and I began reading everything I could about *Titanic*. I would be in the company of experts, so I tried to arm myself with at least some knowledge as I did not want to appear totally uneducated on the subject when I arrived. I ultimately found it a hopeless task but enjoyed my self-imposed crash course. There are scores of professionals and even amateurs whom I consider experts who know far more than I ever hope to about the ship. I quickly realized it was too much to compete with those who had studied *Titanic* all their lives. Instead I would stick with what I like best and concentrate on the imagery and feelings of the expedition from start to finish. It would be the only practical way I could approach this journey and not feel totally lacking in ability.

The one thing I knew would set me apart from most *Titanic* enthusiasts in doing a book was that I would experience *Titanic* firsthand and it would be a part of me as a result.

The journey begins

To reach the spot where *Titanic* sank, St. John's New-foundland is the most practical place from which to depart. *Titanic* sank about one thousand miles east of its New York destination, but to reach the wreck site leaving from St. John's is shorter. It is a journey of only 380 miles due south, and it takes about a day and a half to get there by ship. However, getting to St. John's in the first place is a little tougher than getting to New York. The flight from my home in Clearwater, Florida, took a total of eighteen hours, counting layovers and delays. I survived the tribulation of airport life intact, but my luggage was not as lucky. I was given some hints of *Titanic* disaster as my opened bags came crashing down the luggage chute with cameras, computers, and clothing plummeting in every direction and proceeding to go around and around the conveyor belt for all other survivors to see. I felt like a victim floundering for my life in this carousel of baggage, searching for what was mine while others casually looked on from the safety of their lifeboats as if nothing were happening.

I saved myself as best I could but was too tired to complain to management about the rough treatment of my brand-new luggage, which I had purchased for the trip. I knew it would do no good. Besides, it was three in the morning at the St. John's airport and I was lucky to get a taxi driver, let alone an employee of the airline, to sympathize. I feared my camera equipment, which I would be relying on for reference photos I would later make into paintings, might be damaged. Fortunately, the severest damage was to my pride.

St. John's, Newfoundland

St. John's is the capital of Newfoundland and has the distinction of being the most easterly port and oldest city in North America. Tradition has it that the town was named in 1497 by John Cabot, a Venetian explorer. Newfoundland became England's first overseas colony in 1583 when Sir Humphrey Gilbert laid claim to the island in the name of England, marking the beginning of the British Empire. Enough history!

I had time to learn a little about St. John's because the weather was acting up about a thousand miles to the south. We had hurried to get here as our ship that was to deliver us to the *Titanic* site had, like all ships, a schedule. Unfortunately, Mother Nature had different ideas concerning our plans to head out to the wreck site. August is the season for hurricanes and one was stirring offshore in the area around North Carolina and threatened to be heading north towards *Titanic*. That meant we were forced to stay in port a few days, giving the storm time to make up its mind before any possibility of our heading out.

As opportunities to dive on the *Titanic* don't happen every day, the storm was of great concern. Each day in port lessened my chance to actually dive on the wreck since only a limited number of dives in the submersibles were being made. There wasn't much I could do about the weather, so, with sketchpad in hand, I spent time wandering around St. John's taking in what sites there were to see.

The focal point of St. John's is its harbor. In earlier years it was a busy trading port; now it is mainly a service port. I found it a very handsome place and enjoyed the time I spent there. Buildings sprawled on different elevations along the hilly streets—so unlike the flat landscape of Florida. This presented unusual perspective problems for me as I sketched, but also a chance to have some fun figuring it out as I sat on the cold granite curbstones.

St. John's is full of wonderful winding, steep streets lined with interesting buildings.

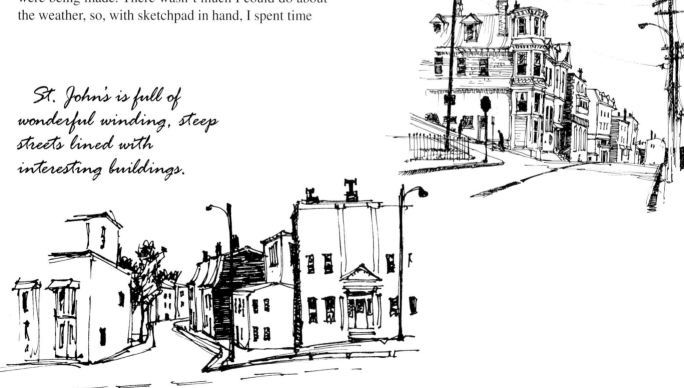

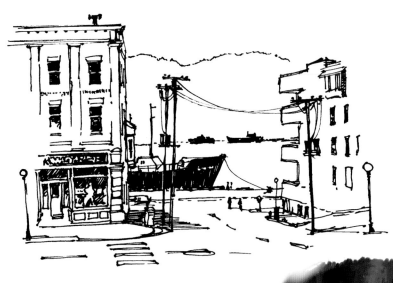

Looking from the downtown towards the harbor, I caught a glimpse of the ship *Explorer*, which would serve as my ride to the *Titanic*.

No matter where you are, flowers have a way of making you feel good.

Being a hot-air balloonist for many years, I am very aware of electrical wires. They are everywhere, and St. John's is no different.

The steep-, pitched roofs are designed to keep snow from piling up on them, quite different from the roofs I am used to seeing in *Florida*.

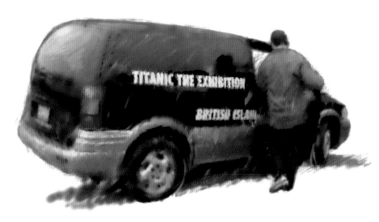

Signal Hill

One afternoon Lowell and I decided to walk up to a place called Signal Hill, so named since the early 1700s because at the top, flags were hoisted on a yardarm, telling merchants which ships were approaching the harbor and giving them time to prepare for the docking. During the nineteenth century, harbor pilots and customs officials also watched for these signals.

As we strolled along enjoying the scenery, the harbor, and the wildflowers, I mentioned to Lowell it would be nice to get a ride to the top as my legs were starting to ache. No sooner had the words left my mouth than a black van pulled up beside us. Lowell motioned to the driver. To our surprise the lettering on the side said "*Titanic* Exhibition." I didn't realize there was an exhibition here in St. John's, and catching a ride from the curator of the *Titanic* Museum seemed like a good omen. At the top we had a great panoramic view of the harbor and the coastline.

Signal Hill was significant in my trip to the *Titanic* because the wireless telegraph used on steamships, including the *Titanic*, began right here on December 12, 1901, when Guglielmo

Marconi and his assistant received the first transatlantic radio signals.

Unlike *Titanic*'s antenna, which was a wire strung between the foremast and aftmast of the ship, Marconi's first antenna was made with five hundred feet of copper wire and held aloft by a kite. The letter "S" (three dots) was transmitted from Cornwall two thousand miles away, proving radio signals extended far beyond the horizon, giving radio new global dimensions for communications.

In 1920, nineteen years after the first transatlantic telegraph signal was received, the very first wireless telephone transmission would be made here by Marconi's company. The tower, named Cabot Tower, was turned into a wireless station owned by the Canadian Marconi Company and operated from 1933 to 1960. Now the tower is open to the public as a museum, gift shop, and amateur radio station.

A sign marking directions to points around the world included "Titanic 365 miles." At least I wasn't lost!

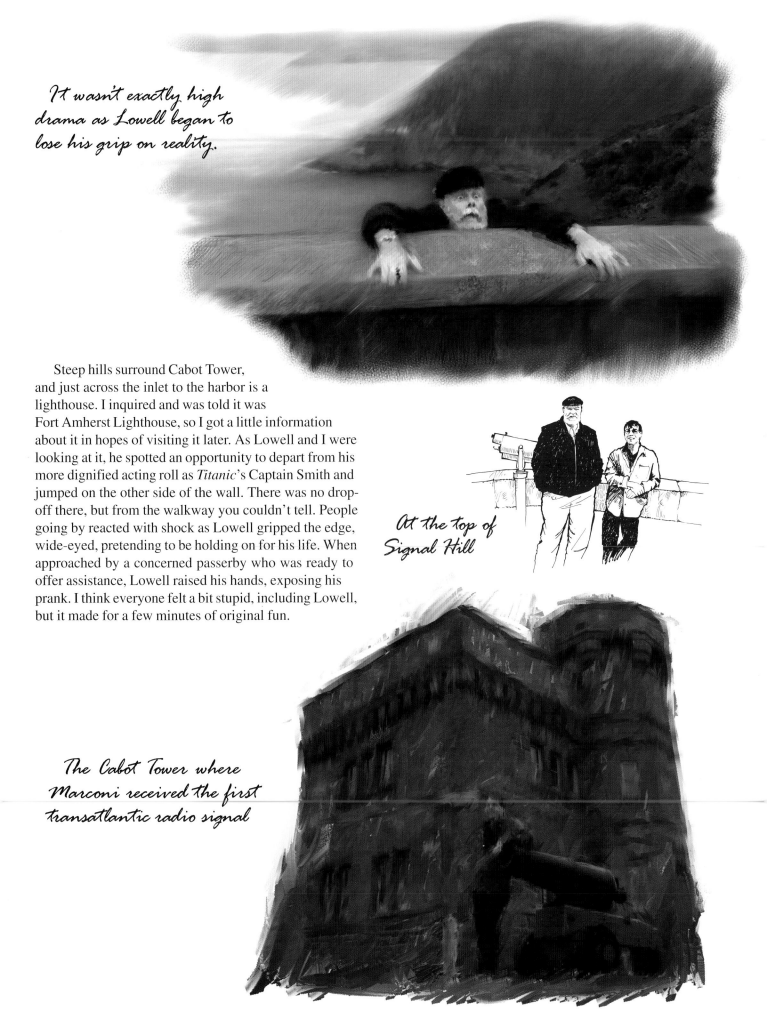

It wasn't exactly high drama as Lowell began to lose his grip on reality.

Steep hills surround Cabot Tower, and just across the inlet to the harbor is a lighthouse. I inquired and was told it was Fort Amherst Lighthouse, so I got a little information about it in hopes of visiting it later. As Lowell and I were looking at it, he spotted an opportunity to depart from his more dignified acting roll as *Titanic*'s Captain Smith and jumped on the other side of the wall. There was no drop-off there, but from the walkway you couldn't tell. People going by reacted with shock as Lowell gripped the edge, wide-eyed, pretending to be holding on for his life. When approached by a concerned passerby who was ready to offer assistance, Lowell raised his hands, exposing his prank. I think everyone felt a bit stupid, including Lowell, but it made for a few minutes of original fun.

At the top of Signal Hill

The Cabot Tower where Marconi received the first transatlantic radio signal

Quidi Vidi

Being the friendly sort, the curator of the *Titanic* exhibition who had driven us to Signal Hill had some time on his hands and he cordially gave us a tour of the area—a nice gesture since we knew nothing about what was of interest. His motivation, I'm sure, was kindness, but I think he may have also wanted some association with those of us going to the *Titanic*. Our tour included a small village called Quidi Vidi, located several miles from downtown St. John's.

This part of the world isn't what you would call a major tourist destination, so most of its natural charm still remains, and the old buildings with their character haven't been knocked down and replaced with fast food franchises. Rock formations several hundred feet high help protect the tiny harbor from storms and the outside world, making it especially delightful. In addition, it boasts a wharf well worn with age and use, lined with picturesque fishing boats.

It is the kind of place I could walk around and take in the beauty and not feel I was trespassing—which I probably was. It had a comfort level you don't often get to experience anymore. The weeds were interspersed with wildflowers, and, fortunately, people knew better than to mow them down. It worked to make a diversity of texture and color planned by nature that couldn't have been more pleasant. Even the name "Quidi Vidi" sounded like it was out of a fairytale.

Being August, the weather was cool and refreshing but not cold. I'm not sure I would have the same sentiments about such a place this far north in mid-December, and, having been a Floridian most of my life, I probably couldn't endure the predictably harsh winters. Just by looking at the people living here you could tell they were rugged enough to stand up to such conditions.

Into the past

Many small houses dotted the village of Quidi Vidi, including the Mallard Cottage just a block up from the harbor. Lowell and I wandered into the old house that had been turned into an antiques store. The door was so low we had to be careful not to hit our heads. Their brochure said it was built in 1750 and was the oldest cottage in the oldest city in North America. Having visited St. Augustine in my home state, I question the claim because the oldest house there was built around the 1720s. I can't remember what month it is most of the time, so to me it didn't matter. Sometimes claims are better left alone. I usually just concentrate on the character and beauty of the subject rather than worry about the historic significance.

I loved the window boxes and did two paintings of them. The flowers seemed to take care of themselves, which may or may not be true. I know whenever I try to grow flowers like this they never end up looking like much. My best bet is always painting these subjects and letting someone else do the gardening.

As we went inside the cottage we were greeted by a girl about ten or eleven years old. She politely told us how the house was built and gave the history of the Mallard family from Ireland as we looked over all the items for sale. It was as if we had gone back in time.

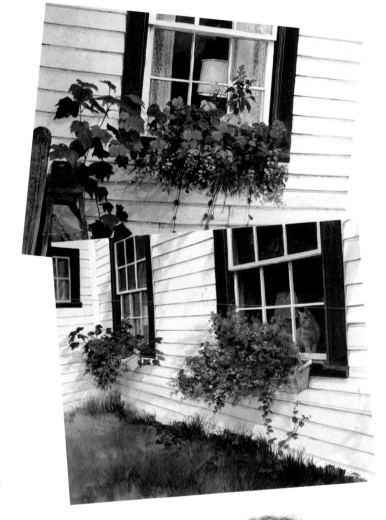

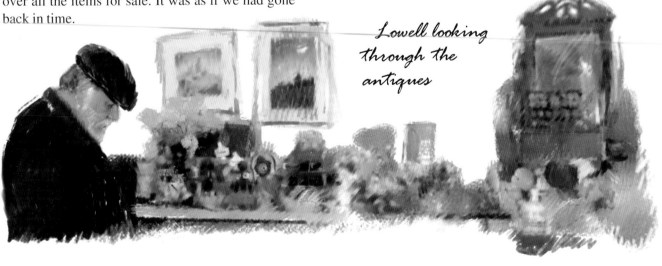

Lowell looking through the antiques

Just barging in, thanks

When James A. Michener did the foreword to a book I did about the Smoky Mountains, we travelled together and would just walk into farmyards and knock on the door of strangers who had an interesting place. I would usually spearhead these unannounced intrusions, but Michener was eager to follow. We would start a conversation that within a few minutes became a friendship of sorts. Seldom did they know they were talking to a famous Pulitzer Prize–winning author. We probably just appeared to be a nosy grandfather and his grandson. Visits like this were quite rewarding, and only a few times were we met with a less than amiable response.

My friend Lowell is also the friendly sort, and we found ourselves having encounters not unlike those Michener and I had had. The best ones took place inside several boathouses where the locals were sitting around exchanging tales about their latest catch or discussing how the town fathers were interfering with their lives—the same sort of conversation that takes place everywhere on earth. I was more fascinated with the character of the men themselves than their dialogue. Theirs were rugged faces carved out by a hard, lifelong work ethic.

There was so much material here for an artist I could have spent several weeks in this small village and loved every minute of it.

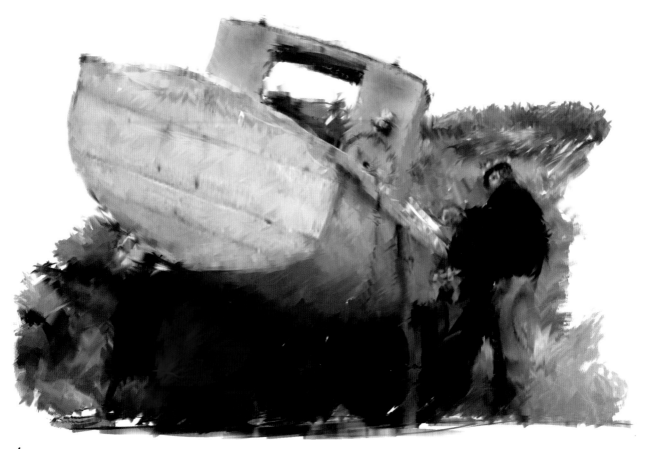

In the meantime

Boats are far more interesting on land than in the water. Their most graceful shapes lie below the waterline. Putting them in water is like cutting a portrait off at the nose. All this appeal was just a way to mark time as I waited to see the most famous ship in the world, one that hadn't been out of the water for generations and would never see sunlight again except in bits and pieces.

In spite of my enjoyable time spent here, my whole being was in high pitch waiting to cast off to visit the *Titanic*. Until then, scenes like this made my stay rewarding. Not living here, I didn't have time to take it all for granted and found it easy to appreciate the fairyland quality of the landscape and the pleasant company of its residents. I felt young with all my worries left behind.

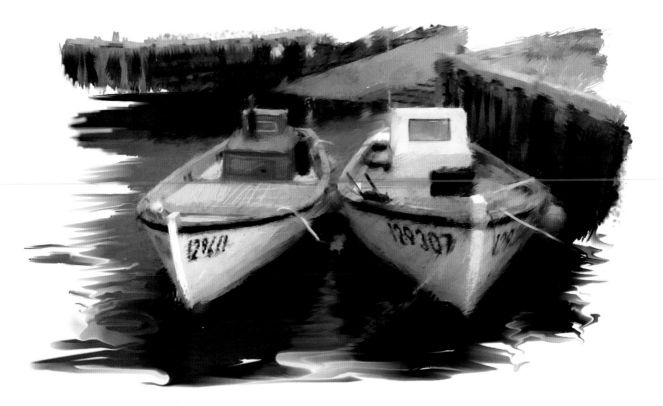

Cape Spear

Having already done several books on lighthouses, I was eager to see all I could of the lighthouses in the area. I was without transportation, so I used my thumb to get a ride. I hadn't hitchhiked in thirty years, but it was something I had done lots of during my college and Navy days.

We were staying on board the *Explorer,* which was to take us to the *Titanic.* As it was tied up at the docks right near downtown St. John's, it provided an easy central location for my start. The sunny morning was perfect for an outing, so I fashioned a sign from a cardboard box lid by printing "Cape Spear" in large red letters on it with a felt pen. On the other side I printed "St. John's" in order to get back. One of the shipmates from England asked to go along, so we set out for the lighthouse with our gear, and within no more than a minute someone picked us up and took us directly to Cape Spear, a distance of about twenty miles. Cape Spear has two lighthouses and is a lovely place to spend a few hours. The oldest lighthouse stands atop the three-hundred-foot sandstone cliffs where we had a breathtaking view of the ocean. Humpback and minke whales swam not far offshore. Built in 1835, this lighthouse had a stone tower with the keeper's house built entirely around it. It was a smart design and made it convenient for the keeper during cold, wet nights.

Cape Spear is the most easterly point of land in North America.

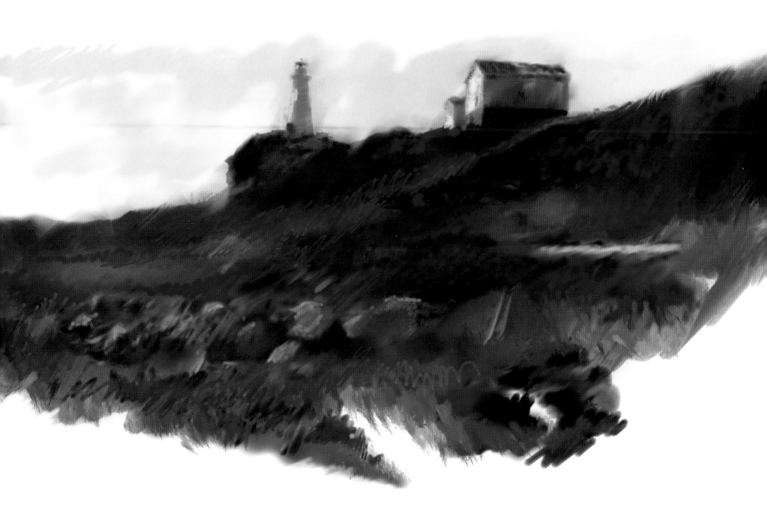

The other lighthouse was built in 1955 and is more traditional-looking. Both were a delight, and we spent the entire morning enjoying the scenery, fresh air, and wildflowers growing everywhere.

Bob, the Englishman who joined me, was about the friendliest guy I have ever met. Everything to him was "higgly piggly," a phrase I'd never heard before. I think it means being scattered and disorganized, but he used it as a replacement for the word "good." When we caught a ride it was "higgly piggly." At the lighthouse he spoke to everyone we passed and may have frightened some by his unusual sociability as he offered assistance to ladies walking up the stairs near the lighthouse and any other kindness he could think of. I enjoyed his company and attitude, as so often just the opposite seems to be the standard of human nature.

Wild roses grew everywhere alongside the roads and in the fields.

The most prevalent flowers growing around the area were these small delicate wild roses. I picked a number of them and placed them to dry in my sketchbook. Later they would become a simple but symbolic part of my *Titanic* adventure.

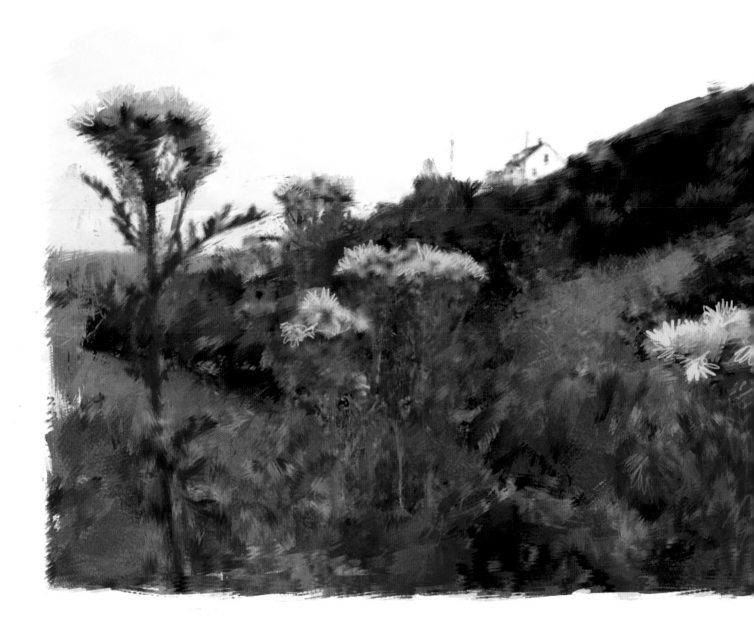

Fort Amherst Lighthouse

We were still on hold in St. John's, waiting to see what that hurricane to the south was going to do. So having more time on my hands the day after visiting Cape Spear, I once again packed up my cameras, tripod, sketchbook, and a small lunch and decided to do more exploring of the area by hitchhiking over to the Fort Amherst Lighthouse. It was just at the mouth of the bay, so the trip there wouldn't be a long one, only a few miles. I'm not a very good walker so I made another small sign of cardboard saying "Port Amherst," and off I went.

I found I could hook the tripod to my belt to free my hands, and it wasn't long before I devoured the sandwich, freeing up my maneuverability even further. It was only moments before someone picked me up, but it took several short rides to go the distance. I walked the last

part, noticing small things as I went. As I'm writing this and looking at the landscape painting of the lighthouse with the bumblebee in the foreground, I can tell you that on the entire *Titanic* experience, including the dive, there is scarcely anything that can compare to the beauty and inspiration of the often-neglected magnificence of every-day nature. As an artist, these small things make up the largest part of my wonderment, and if I never saw the *Titanic*, sights like this would be fulfilling enough to satisfy every artistic sense I would ever have.

Quietly observing the variety and beauty of life busying itself on every leaf growing here rewarded my efforts. Even if I hadn't taken into account the life and movement of it all, an abstract view of the beautiful colors and shapes alone is almost more than I could comprehend.

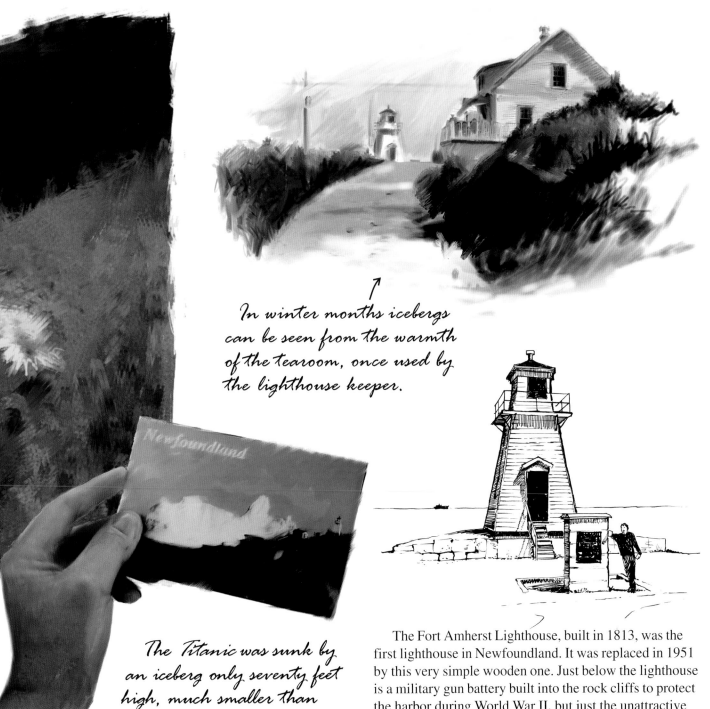

In winter months icebergs can be seen from the warmth of the tearoom, once used by the lighthouse keeper.

The Titanic was sunk by an iceberg only seventy feet high, much smaller than the one pictured in this postcard as it drifted by the mouth of the St. John's Harbor. The night Titanic sank there were icebergs in the area much larger than this; some were two-hundred feet tall. Why Titanic arrogantly steamed through an area with ice like this is a total mystery to me.

The Fort Amherst Lighthouse, built in 1813, was the first lighthouse in Newfoundland. It was replaced in 1951 by this very simple wooden one. Just below the lighthouse is a military gun battery built into the rock cliffs to protect the harbor during World War II, but just the unattractive concrete gun emplacements remain. Both structures are meant to save lives—well, depending whose side you are on—but it makes a strange contrast between the lighthouse, with its sole purpose to save lives, and the bunkers, whose purpose is to take some lives in order to protect others.

About a hundred feet from the lighthouse is the keeper's house. It has been made into a delightful tea room. I was content spending several hours here enjoying the cool air blowing off the Atlantic. Whale-watching tour boats and rugged fishing boats entering and leaving the harbor made the stay even more pleasant.

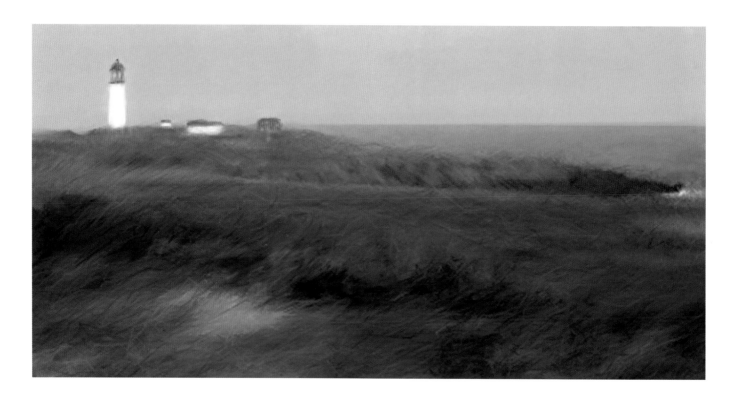

Cape Race Lighthouse

In the 19th and early 20th centuries, just about every ship departing from Europe for the New World set its course for the Cape Race Lighthouse. Located on the southeast coast of the Avalon Peninsula south of St. John's, it was the first landfall for millions of immigrants coming to the New World. Travel was often hazardous during those earlier times because the science of navigation on the seas was dependent on only a few simple instruments.

Lack of forecasts, unpredictable weather, dense fog, arctic ice, and high winds were responsible for the wreck of almost a hundred ships and the loss of thousands of lives on the nearby black slate cliffs. I can tell you firsthand a lighthouse is entirely useless when there's fog.

Even as the art of shipbuilding reached a mature stage, disasters still occurred. The biggest example, of course, is the *Titanic* plowing full speed ahead with the knowledge icebergs had been reported in the area. Some disasters were due to bad judgment, while others were simply the result of bad luck. Each generation fails in many ways to learn from the past and has to find out firsthand what nature is capable of. It may be especially true when it comes to dealing with the sea. The ocean is a bad place to take on Mother Nature in hopes of always winning. It's just too big and powerful a competitor.

But this lighthouse certainly prevented many catastrophes that might otherwise have occurred. By 1907 the original iron lighthouse was showing its age and was replaced with a concrete tower, and a much improved

seven-ton Fresnel lens was installed in the lantern room.

The lighthouse was not the only important piece of business going on at Cape Race. In 1910 the New York Associated Press had an office at Cape Race to relay their news stories from Britain to New York. It played a part in the story of the *Titanic* as well. Robert Huntson, the operator of the Cape Race station, received messages from the *Titanic* at the time of the tragedy. He took notes that later revealed that at 10:25 P.M. EST on April 14 the *Titanic* distress signal was heard. At 10:35 the *Titanic* called the *Carpathia* and said, "We require immediate assistance." At 10:55 another message was picked up: "Have struck iceberg and sinking." At 11:36 the *Olympic* contacted the *Titanic* requesting its coordinates. *Titanic* replied, "We are putting women off in the boats." At 12:50 April 15 the *Virginian* told the station that it had lost contact with the *Titanic*.

All in all, Newfoundland, after having appeared to be a strange place to originate a journey to *Titanic,* was in fact not only the nearest location to the wreck but a fitting historical location from which to begin.

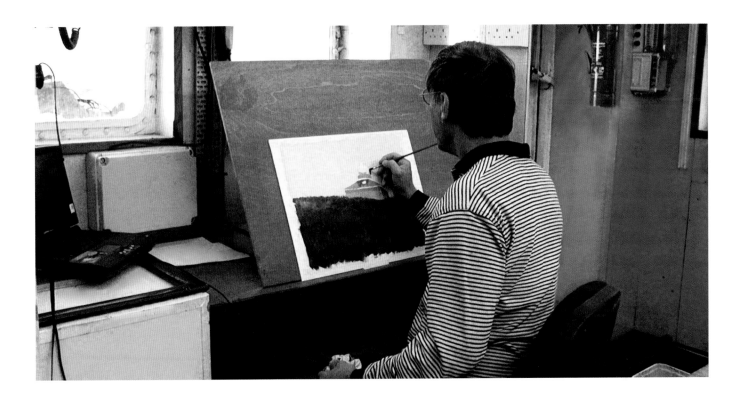

Painting and waiting

When I left Florida, I assumed I would be transported to the *Titanic* in a boat maybe the size of a shrimper. I envisioned being stuffed into a small space along with a few dozen others like sardines being brought to market and hadn't imagined the *Explorer* would be a hundred fifty feet long with private accommodations.

Waiting in port was very comfortable and the food was good. The ship was grossly oversized for the job of taking us out to the *Titanic*, but I had no complaints. There was plenty of space and extra rooms available for

Even though the Explorer was still in port, I sat on the dock and painted it as if it were at sea.

me to set up my studio to begin work, and, having hitch-hiked around town about as much as I wanted, I decided to get started. Most books are written and then illustrated, but I approach my books quite differently. All the paintings and drawings are done first. Then I sit down and write about what I have painted. My mind works backwards that way.

At this point no one knew how much more time we would still have in port before we could leave, so I settled in and began working on painting the lighthouses I had seen. I work primarily from photographs I take, but I tried to do as much sketching and painting as possible as I went along. Painting from life is good when the objects don't move, like lighthouses, but when trying to capture people and activities around the deck of a ship, I find a camera is a good companion to have along. It acts as my memory, and from those shots I can pick and choose the moods and feelings I want to extract into paintings. I also decided at this point to use technology and paint many of the images with the aid of a computer tablet.

I claimed an empty room on the ship for my studio and finished several paintings of the lighthouses. I also sat out on the pier and did a rather large painting of the *Explorer*. Everyone seemed to enjoy my progress—someone more than others since the painting disappeared after it was finished. I hope that someone, somewhere, is enjoying it. I never got around to signing it, so if whoever has it reads this: Feel free to forge my signature on it too.

23

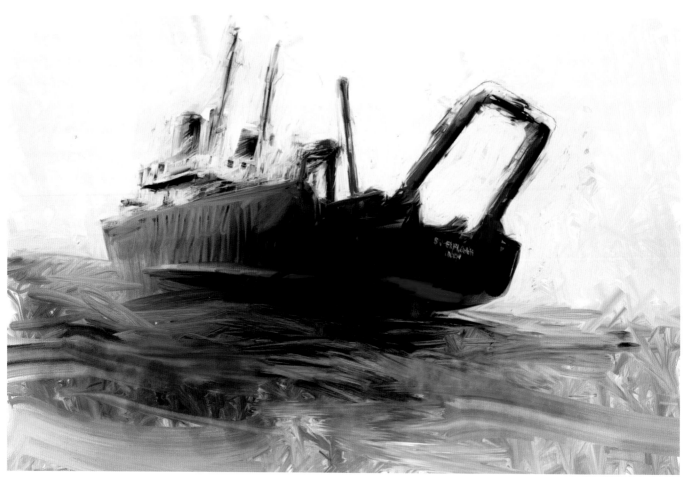

The *Explorer* on its way to *Titanic*

We had waited four days for the hurricane to decide if it was going to continue to wander in circles just to the east of the Carolinas or drive its way up the coast into our path. The weather had already begun affecting operations on the Russian research vessel, making it impossible for the submersibles to dive, and we learned that the Russian ship had moved away from the area of *Titanic* to avoid the worsening conditions.

The entire trip to the *Titanic* appeared to be in jeopardy. All the anticipation of being able to get to our destination centered around weather maps and television reports. Two television reporters from Florida were here to go along on the expedition, and they were able to monitor the weather much better than anyone else on board by direct contact with their television weatherman in Tampa. But as unpredictable as hurricanes are, their future direction is anyone's guess, no matter how good the forecasting.

The hurricane finally moved up the coast and passed only a hundred or so miles from the *Titanic* but luckily kept going northeast, opening up the way for us to leave port. All the sightseeing of St. John's was left behind as we sailed from the harbor and passed the lighthouses I

had visited. Seeing them from the bow of a ship gave them a whole new meaning and presented me with a better perspective of their significance and purpose. The sea was not choppy but rather had large, rolling swells from the hurricane, which I found comforting . . . at first.

My unpleasant thoughts of ship life from earlier days in the Navy did not apply to this trip. It felt like this entire journey would be one of joy. I then developed a slight headache followed by that little funny feeling, and before

One of the great pleasures of being on a ship is eating—and getting to know the cook.

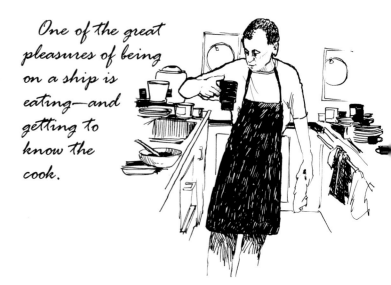

I knew it—full-fledged seasickness. Anyone who has ever been seasick knows there is nothing funny about being in such a condition. For me it lasted the entire time it took to reach the *Titanic* site. If only I had installed that seemingly insignificant seasick patch behind my ear a little sooner—why I didn't, I'll never know.

In the Navy or on a cruise ship, one of the best parts about being at sea is eating. Eating and being seasick, however, are not a good combination. The dining hall just happened to be right across from my room, and as much as possible I tried to enjoy the chef's cooking by foolishly eating the rich foods that are so difficult to resist.

In spite of my motion sickness, I did manage to spend time on deck watching whales in the distance and up close, but mostly I listened to the waves slapping against the side of the ship from the horizontal position of my bed. It's a strange thing about being seasick: when you're lying down you feel okay. As soon as you get up, you feel like you are going to die and wish you were. I managed somewhat to keep my sickness to myself, not wanting the others to know this early on in the game that I was no sailor. It was bad enough I wasn't an expert on the subject of the *Titanic*.

I felt as green as my shirt after being at sea only a few hours.

While most of us were sleeping, the Explorer continued to steam its way to the Titanic. By mid-morning we would be at the site of the most famous shipwreck in the world.

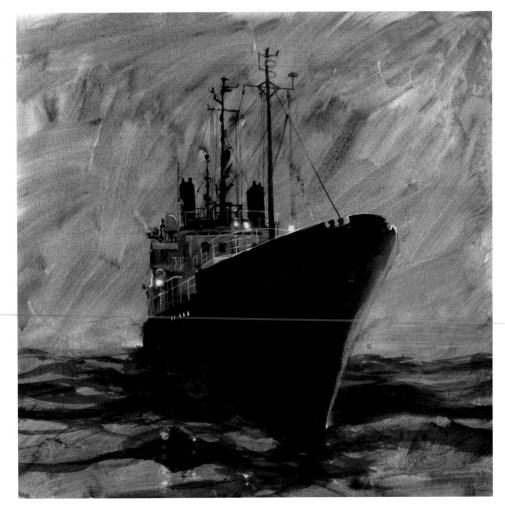

25

Getting in the mood

The times I got on deck I would sit in the shade by the auxiliary anchor looking out at this endless ocean. Others would sit near the bow on the anchor chains. I wondered what it would have been like to be out there in freezing water in the middle of the night with no rescue in sight. How a great ship like the *Titanic* could sink and disappear beneath the ocean is just beyond what my mind is capable of comprehending.

At that point, other than feeling sick, I had nothing but good things to look forward to in the upcoming days. Being at the *Titanic* was not yet a reality, so all my thoughts were just that, simple pictures in my head. Those of us who had never made the dive to *Titanic* really didn't know what to expect. It would not be long before I would actually be at the spot where it all happened and a much different reality would replace my current thoughts.

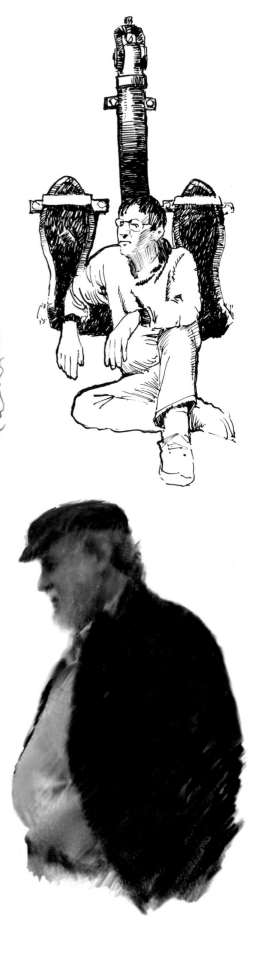

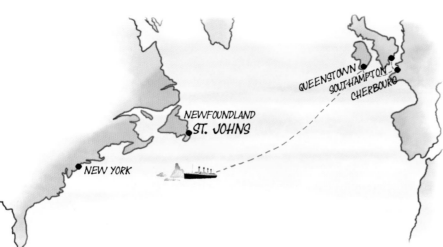

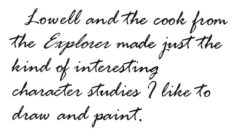

Lowell and the cook from the Explorer made just the kind of interesting character studies I like to draw and paint.

26

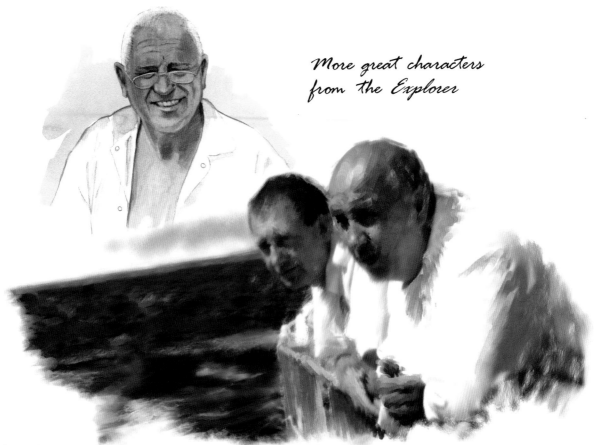

More great characters from the Explorer

Fitting in

I believe it takes a special type of person to call the sea home. First of all, work has to be done as a team and not as an individual, and although I was in the Navy, I never totally got used to that idea. Artists are not great at team efforts. I suppose it's because art is a very personal and individual thing, so artists tend to get comfortable working alone. Being on a ship requires all that be put aside so everyone can work as a unit. It can't be any other way, or disaster would be sure to follow.

Some people are leaders, some followers, and some don't fit in either category. Keeping in step with society and not being either one requires being somewhat of an artist. Fortunately for me, people expect artists to be a little on the outside. I try not to use it as an excuse, but it sometimes helps in a pinch. I'm more of an observer than a participant. I take what I've seen and express it in the form of paintings that may or may not touch others. I just like what I do and don't really bother about its acceptance.

But back to being on board the ship . . . I seemed to fit right in with the crew of the *Explorer*. It was quite easy since they were all so friendly, and many of them were a bit on the outside as well. My sketching intrigued them, and there was no shortage of interesting faces to work from. Most of the men were from England and had been calling this ship home for a long time. It was obvious they enjoyed having new people arrive. It almost felt like a bed and breakfast where they did all they could to be cheery and accommodating.

The seasickness patch began to kick in and do its job. Things were looking up, and as I felt better I began enjoying the company of the shipmates. They always had tales of the sea ready for anyone willing to listen. Having time on my hands, I found their anecdotes, legends, sagas, tales of romance, and rumors from other *Titanic* expeditions a great source of entertainment.

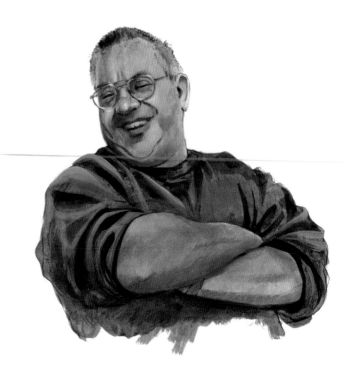

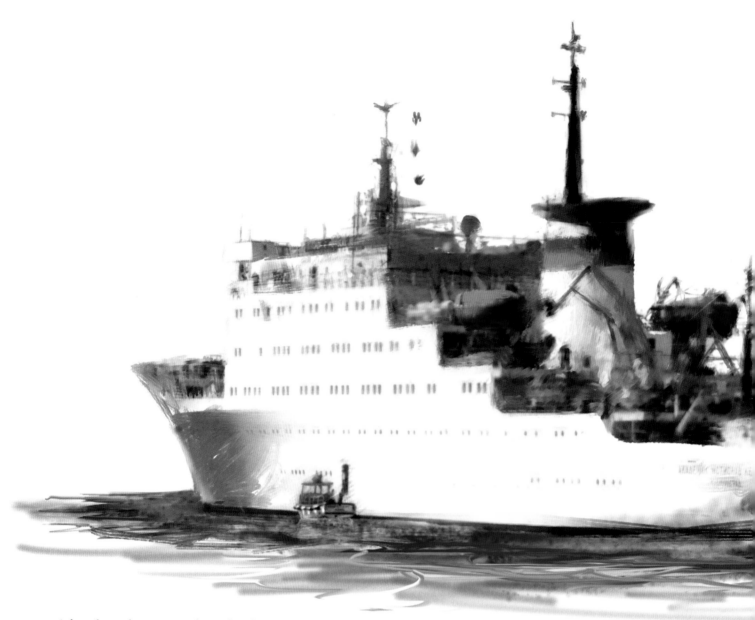

Akademik Msistlav Keldysh

On the afternoon of August 15, after a thirty-six-hour journey we arrived at the Russian research vessel *Akademik Mstislav Keldysh*. This beautiful white four-hundred-foot vessel fitted for ocean research glistened like a jewel on the deep blue waters of the North Atlantic as it lay about a quarter of a mile away when the *Explorer* came to a stop.

Moments later the launch from the *Keldysh* motored over to pick up all of us new arrivals. I donned my cumbersome lifevest and clutched my suitcases, which were full of cameras, sketchbooks, paints, canvas, and more cameras, along with a few clothes that my wife, Sarah, thought necessary for a trip of two weeks.

I had finally arrived at the exact position where *Titanic* had sunk the night of April 14, 1912. Nothing looked unusual. It was still just water all around like any other spot on the ocean, but in my mind and heart I knew this pinpoint of a place was quite different from any other.

Once on board the *Keldysh,* Lowell and I were shown the room we were to share. Finding the way around a new ship is always difficult, but once again my room happened to be directly across from the dining area, or mess hall, as sailors like to call it. I've never liked the term. We unpacked a little but basically lived out of our suitcases. The camera and computer equipment took up most of the desk along with the battery chargers carefully selected with the right electrical adapters to accommodate the Russian outlets and electrical system.

The *Keldysh* is a very stable and solid ship, and there was little sensation of movement on board. A few times during my stay the seas reached about fifteen feet, but with the help of my seasick patch I established a set of apprentice-grade sea legs, enough to make me feel at home. I have to admit I was glad to get off the smaller ship and plant my feet on the decks of this larger vessel.

The *Keldysh* is the world's largest research vessel and carries with it two of only five submersibles in the world able to reach the depths at which *Titanic* rests. On board the ship are seventeen laboratories for various scientific activities.

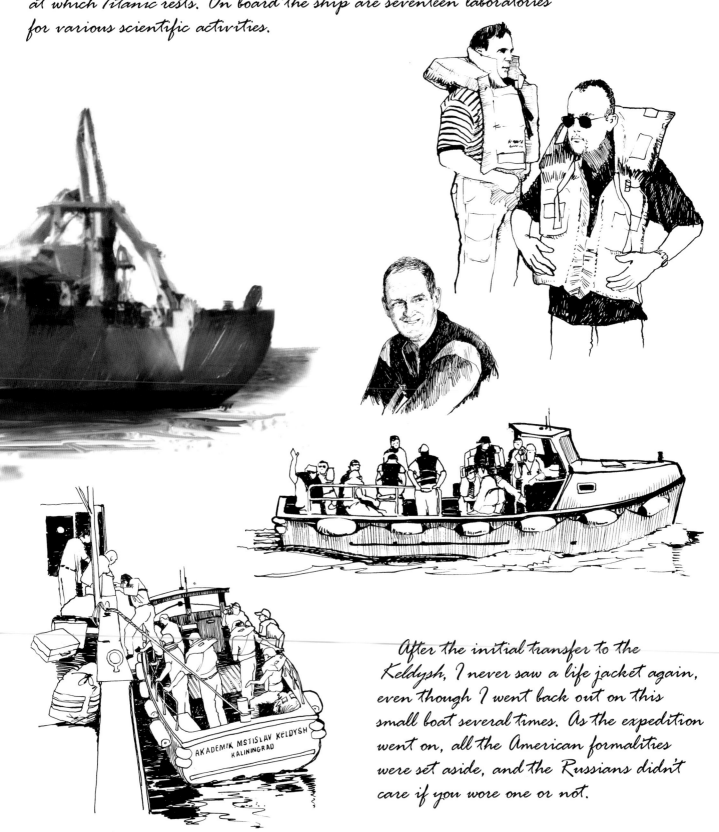

After the initial transfer to the *Keldysh*, I never saw a life jacket again, even though I went back out on this small boat several times. As the expedition went on, all the American formalities were set aside, and the Russians didn't care if you wore one or not.

The *Mir*

There are only a few submersibles in the world with the ability to reach the depths of *Titanic,* and the Russians have two of them, *Mir I* and *Mir II.* "Mir" is the Russian word for peace. Both are based on board the *Keldysh.*

Even though they look like something from a Saturday morning cartoon, they are marvels of achievement able to withstand pressures of 10,000 pounds per square inch and reach depths of 20,000 feet. The subs were constructed in Finland in 1985 and 1987 at a cost of $20,000,000 each.

The outside housing is bullet-shaped, measuring twenty-six feet long and ten feet high, but the actual passenger compartment tucked inside the shell is a perfectly round sphere only 6.8 feet in diameter. Made of hardened nickel steel almost 2.5 inches thick, it can house three people for a total of eighty-two hours using rebreathing units.

Each *Mir* weighs 18.6 tons. Power is supplied by a bank of batteries. Its propulsion comes from one large hydraulic thruster located on the back for forward motion. It also pivots side to side for turning. Two smaller thrusters are mounted on each side and pivot up and down. They can also be used independently to aid in turning, but their main purpose is to give the *Mir* the ability to move vertically. It has a top speed of five knots, but while exploring the *Titanic* it generally moves at a snail's pace.

The ballast relies on transferring water into large onboard tanks and pumping it back out when it's time to surface. If that fails, 771 pounds of steel shot can be released from the underside of the *Mir,* giving it enough buoyancy to get back up.

For this expedition, one still camera and two video cameras were mounted on the front. Two mechanical arms are used to pick items off the ocean floor. The *Mir* can hold 639 pounds of whatever the arms pick up to be carried to the surface in two small metal baskets mounted between the arms.

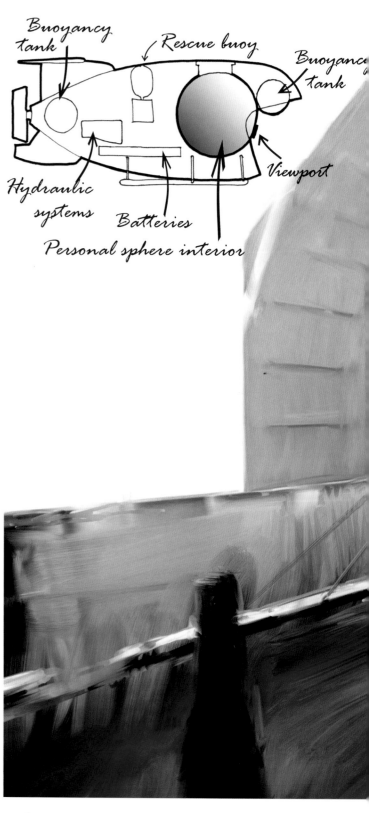

One of *Mir's* mechanical arms

Everything concerning the expedition to retrieve artifacts rested on the *Mir* working properly. Otherwise, the entire project would come to a stop.

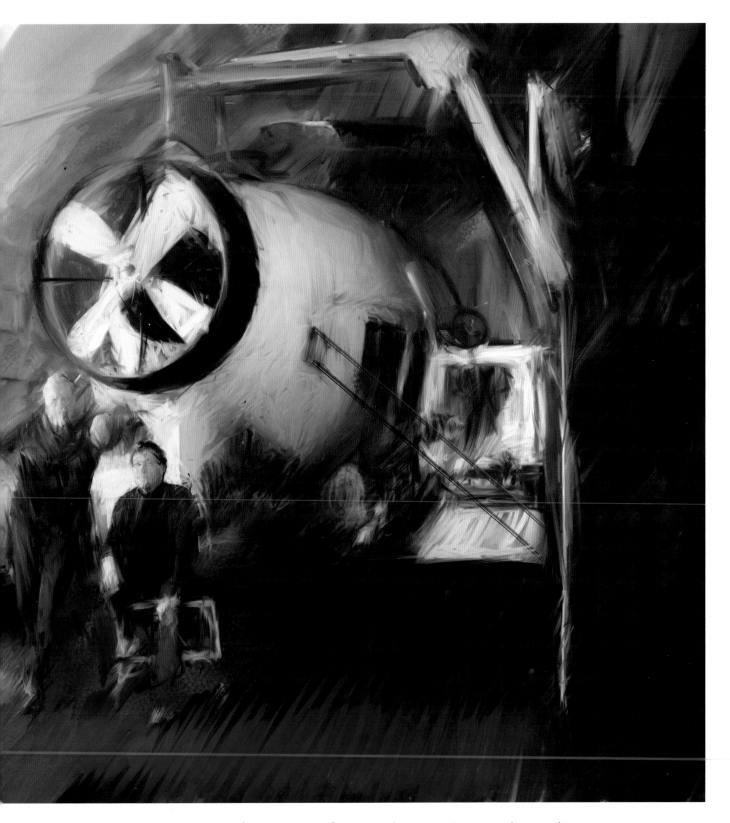

Lowell and I posed by one of the submersibles, knowing, or at least hoping, our opportunity to dive to the *Titanic* awaited us in the upcoming days. At this point it was uncertain since the hurricane had delayed our arrival.

Mike Harris was the one who wanted a writer and artist to visit the Titanic site. I just happened to be the lucky one. My whole trip was due to his generosity and kindness.

Initiation

My initiation to *Titanic* began in the conference room. It was an official sort of briefing about the dive to take place the next day. Many members of the expedition had arrived several weeks before I did, so being at the meeting was somewhat like going to boot camp not knowing what to expect or what was expected of me. As it turned out, nothing was expected of me except common sense and courtesy. Lowell and I were free to wander around the ship and do pretty much as we pleased. As guests we had no specific assignments—in fact, we had no assignments at all. We would simply enjoy the show.

I tried to read up on the *Titanic* before I left home and even put together a plastic model with about a million pieces just to get familiar with the details of the ship, but the more I read, the more I had to admit to myself there was no way I could even scratch the surface on what there is to know about the *Titanic*. I didn't want to appear totally ignorant to those already out there, but as it turned out, nobody really cared what I knew or didn't know. To some degree I got over being the uneducated *Titanic* passenger and found out others had their own personal problems, some much worse than mine. I stuck to that which I knew best—painting, drawing, observing, and taking lots of photographs. I understood my own goals and tried to make the most of my time.

Every day would offer new experiences, and I would hear rumors of intrigue going on behind the scenes. *Titanic* is thought of in many ways. To some it is a resting place that should never be disturbed under any circumstances. To others it is a challenge, a prize, and something to conquer. The motivations include greed, money, and a sense of power. Sometimes egos clashed, and when that happened I disappeared into the shadows.

I avoided all association with whatever was going on the political front with personalities involved. Instead, I soaked up all the meaningful adventure. As a guest I was in a unique position to do so. The underlying purpose of the expedition was to retrieve artifacts for people around the world to view and remember *Titanic*. Personally, I think that's a worthy endeavor.

I had been graciously invited by Mike Harris to go on the entire six-week adventure, but I had chosen my family and other responsibilities first and had hopped onto the ending part of the expedition. In my Navy days I was stationed on an aircraft carrier, which I personally found to be a miserable experience. I could have had a worse assignment, but the military wasn't my lifestyle of choice. I sometimes look back wondering why I didn't try to enjoy the excitement of it more, but at the time I was nineteen years old and wanted to do other things with my life. Maybe those events also played a role in my decision to reduce the time at sea. But this expedition, I found out, was very different from my former sea time. I wasn't under anyone's command. It was more like being on a working ship under cruise ship conditions.

My only responsibility was to show up at mealtimes. I could sleep whenever I chose, and although sleeping was not a priority, just knowing I could take a nap when I wanted was a nice feeling. Activities concerning the mission went on throughout the day and I took them in with enthusiasm. Just exploring the ship was an adventure: the bridge, engine room, and even the KGB room where radio equipment was once used. There were other guests on board, for example the news reporters, who shared my freedom. They did their jobs as I did and were basically on their own, but most had specific duties that required constant attention.

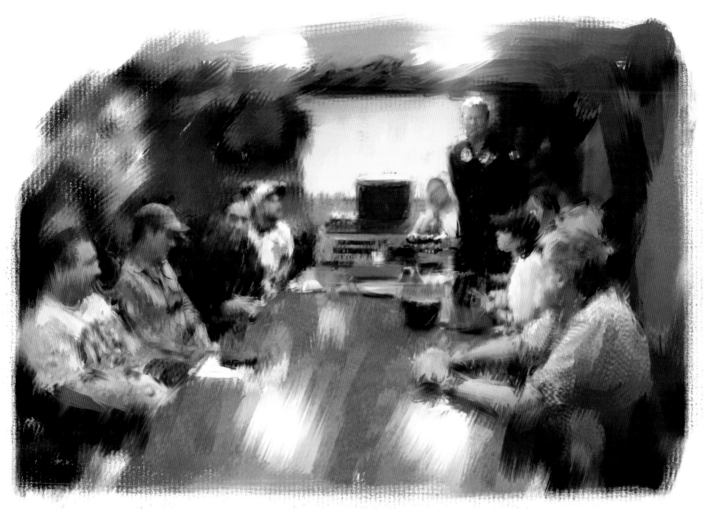

The briefing room

I spy

In the old Soviet days there were KGB agents on board the *Keldysh,* and their radio equipment was located in a tiny room right across from the conference room. Back then, known KGB agents and undercover agents were part of the ship's roster, always on board and always listening. The radio equipment was used to broadcast patriotic songs and speeches to the crew through a public address system, but the system had another more subtle use. Wired to all parts of the ship, including the crews' quarters, it functioned to secretly monitor everyone's conversations, and any anti-Soviet activities would be reported to the authorities.

Now the door to what the Russians call "the room" is always left open so the crew can see that no one is listening to them. Sometimes I would step inside the room for a moment as I walked by. It made me feel fortunate not to have ever lived under such scrutiny.

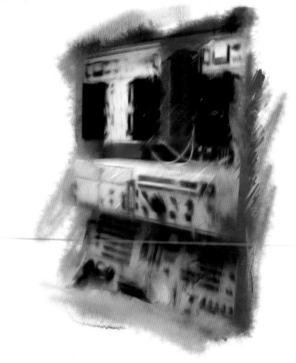

"The room," where the Russian KGB once monitored onboard activities

How we remember

Activities on board the ship were, of course, numerous and varied. For some, their job was to record on film every detail regarding the mission. Even those whose job didn't require taking pictures usually had cameras strapped around their necks, eager to capture remembrances of the trip.

Photography was just beginning to become popular in the era of *Titanic*. I am sure people on the *Titanic* took snapshots during the first couple of days the ship was at sea. As I took my own pictures on the deck of the *Keldysh*, I wondered what pictures might have been taken by the passengers on the *Titanic* and if some pictures might have been taken after the ship hit the iceberg or even as the bow began to lower into the water. As fascinated as people are with pictures, it seems likely some may have been taken but just didn't survive.

Everyone now has either a 35 mm camera, a new digital camera, or some sort of video camera. How different our images and impressions would be today of a *Titanic*-like tragedy. People all around the world would be watching it unfold live on television, and soon aftwards a made-for-TV movie would be ready for consumption.

Jason was filming for a television station in Florida. I had my small digital video camera with me and was happy not to be carrying around heavy equipment like this.

Picture-taking was not confined to the ship. Anyone who dives on one of the submersibles takes a video camera, and hundreds of hours of tape needed to be catalogued. That was the job of Greg Zink, who spent hours each day in front of video editing equipment.

This is Mike's mike. He's the sound man who had an affection for his "furry" microphone.

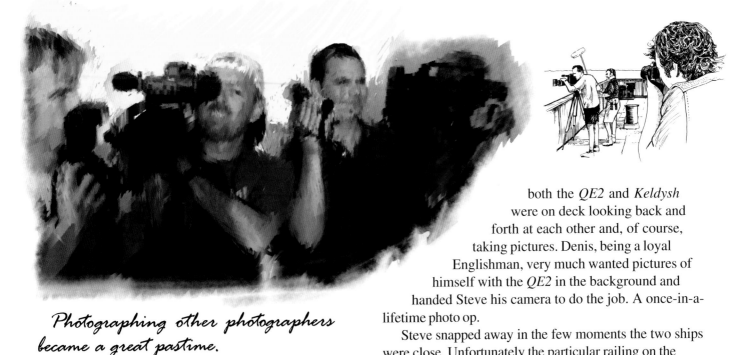

Photographing other photographers became a great pastime.

Picture this

A musician by profession and a natural comedian, Steve Tanner was on this expedition to photograph activities with a 35 mm camera. I don't think he was prepared to shoot as much as he did and ran short of film, so I gave him a dozen or so rolls of my film to get him by. I used a digital still camera for all my photography but brought as a backup two 35 mm cameras just in case my electronic cameras decided not to cooperate. I love the electronic stuff, but it does have a way of not wanting to work when you most need it.

Denis Cochran, an austere Englishman who always wore a suit and tie, was the formal one on board the *Keldysh.* He knew *Titanic* inside and out and could tell you the names of everyone on board. He was an information marvel on the subject, and endearingly pompous.

One afternoon the *Queen Elizabeth,* en route to New York, went out of its way to travel by the *Titanic* site and "rendered honors at sea" in the form of blowing the ship's whistle and dipping the ship's colors. All passengers on

both the *QE2* and *Keldysh* were on deck looking back and forth at each other and, of course, taking pictures. Denis, being a loyal Englishman, very much wanted pictures of himself with the *QE2* in the background and handed Steve his camera to do the job. A once-in-a-lifetime photo op.

Steve snapped away in the few moments the two ships were close. Unfortunately the particular railing on the bridge had gaping spaces built into it to deflect the wind. Not noticing these voids, Steve set Denis's camera down at one of these spots and Denis's precious images swiftly plummeted forty feet to the deck below, vastly overexposing Denis's images as the *QE2* steamed out of sight.

Steve from America and Denis from England were worlds apart in their approach.

secondary. I would drop in occasionally to ask her to send my e-mails home or simply to say hello. I could see she was always busy putting out intricate and complicated fires set off by *Titanic*'s ability to bring out the worst in people.

Valerie has been involved with the *Keldysh* and the Russians on several other occasions as a writer and publicist and has been from Mexico to Africa on board the *Keldysh*. She has been to a depth of 18,000 feet in the *Mir* submersible off the coast of Africa, deeper than any other woman in history. She has written books on diving; was co-expedition leader during the making of the movie *Titanic;* and even though she has been on several *Titanic* expeditions in the *Keldysh*, she was never given the opportunity to dive to *Titanic*. I didn't know at the time of my dive she had never been down to see it and just assumed she had done so many times. It would have been easy for her to be a little resentful, but it never colored her friendly attitude that a novice like myself was here to dive. Valerie was ever the selfless, compassionate one, which is probably why everyone came to her with his problems.

Valerie operating the satellite phone to download e-mails to the Keldysh

Keeping afloat

Communications with the outside world are important to any expedition, both to keep those on board in contact with those at home and to keep the gears of publicity grinding for the newspapers interested in the recovery of artifacts. Valerie Moore was in charge of those duties. Her official title was director of marine operations, but keeping peace around the ship—with everyone who had political ambitions or gripes they couldn't resolve quietly or keep to themselves—ended up at her doorstep. She became so inundated with this occupation that her real job became almost

Ralph White played a large role in the expedition. His room was also open to everyone. From my point of view, Ralph and Valerie were the glue that held the day-to-day operation together.

36

I was fascinated by all the high tech deep sea equipment. I didn't know much about it, but it gave me a sense of security . . . until I saw the stern propeller shield being repaired with duct tape just before a dive.

The Russian crew

One morning I saw the submersibles launched and later in the day I watched as they returned with items not seen since the day *Titanic* sank. My attention was focused on the dives but also on the people calling the *Keldysh* home.

The Russian crew numbered about fifty, including officers, along with another twenty to twenty-five who worked exclusively with the *Mir*. It's a requirement for the crew to speak at least some English to get a job on the ship, but for most of them English was limited–even though it was *much* better than the skill of the Americans to speak Russian. In fact, no American knew one word of Russian except Ralph White, who knew just a little. We all managed to get by with simple nods and accompanying smiles while walking in the passageways. It seemed sufficient to convey goodwill.

The captain and officers of the *Keldysh* were in charge of the ship, but the ship was run by the crew, as all ships are. I saw much more of these men and women than I did the officers, and looked on as they performed their daily tasks, particularly as they put in all their efforts to get the submersibles launched.

Pirate Skippy and the deck crew

The Americans took it upon themselves to give nicknames to the Russian crew. "Pirate Skippy," a name denoting a sort of light-weight cartoon character, was exactly the opposite of what he actually was—extremely rugged and muscular. Always squinting, he had a silver tooth that would catch the sunlight and flash almost like a special effect in a "B" movie. His presence stood out from all the rest as he lifted weights on deck. He looked as if he could have been in the Olympics, and I'm sure he could make a fortune as a wrestler on TV if he ever decides to come to the United States.

It was unusual to see the Russians relaxing. Most often they were busy and hard at work.

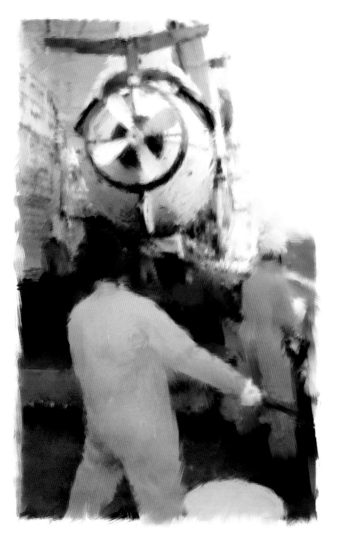

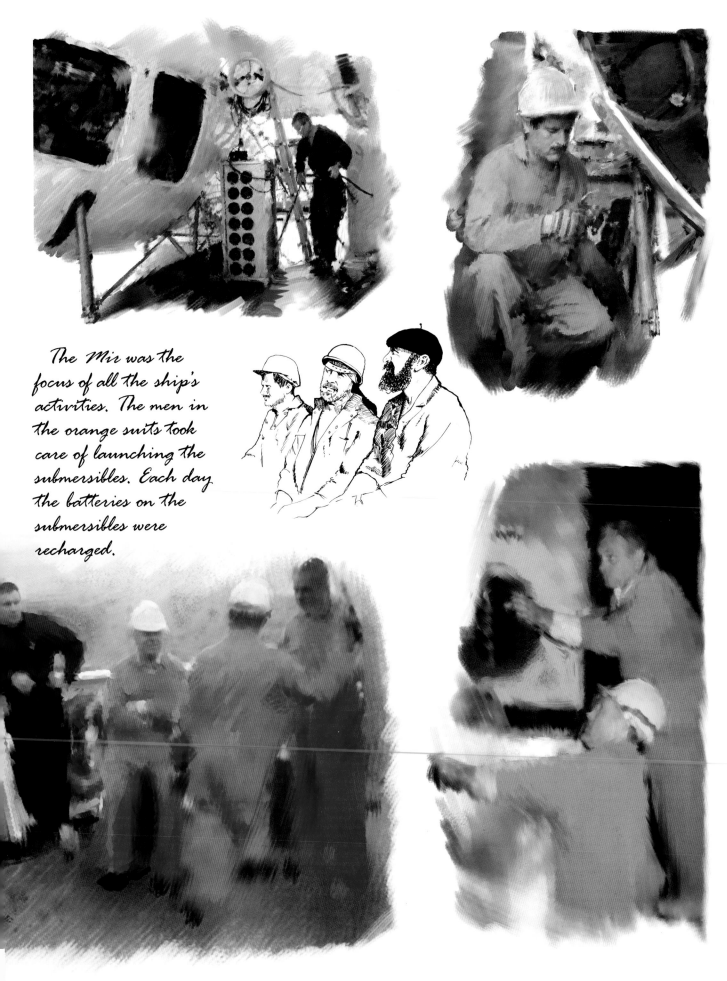

The *Mir* was the focus of all the ship's activities. The men in the orange suits took care of launching the submersibles. Each day the batteries on the submersibles were recharged.

Acts of kindness

This is Sergei, one of the Russian crewmen, better known as "Pierre, the Bird Man." All the Americans on board called him Pierre because of the French beret he wore. We didn't speak Russian and he didn't speak English, so I guess one name was as good as another. He had important duties as part of the diving crew, sort of as an apprentice or understudy in operating the submersibles in hopes of one day becoming a pilot.

I didn't know his exact duties as he worked on the subs taking things apart and putting them back together, but knew him best for a job he had taken upon himself as custodian and keeper of the storm petrels that made their home on board the ship.

Petrels are very interesting birds. About the size of large swallows, they live almost entirely on the open sea and can be found throughout the world. The only time they come to shore in their entire lives is to breed. They are very solitary and not often seen, but some ornithologists believe storm petrels are the most abundant birds on earth—even more abundant than the now-extinct passenger pigeons, of which there were once literally billions. There were so many passenger pigeons they would darken the skies for a week at a time back in the 1800s. If as many petrels exist as scientists say, it just goes to prove how vast the ocean really is.

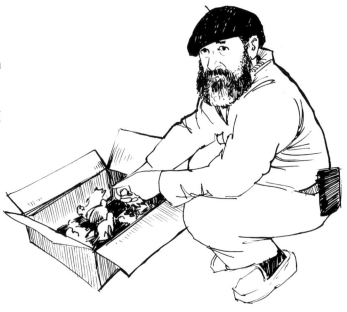

Petrels survive directly from the sea, feeding on small crustaceans called copepods and krill, which are like small shrimp, the same food that baleen whales depend on. An acute sense of smell lets them locate food sources from miles away. When feeding and facing into the wind, they can hold a stationary position in flight. As they patter and drag their feet in the waves, they look like they're walking on water.

Petrels find it convenient to scavenge food from ships, especially when it's thrown overboard. Of course, nothing whatever is tossed overboard while the *Keldysh* is over the *Titanic*, but the birds remain around the ship during the day, and in the evening find small niches to roost in for the night.

Pierre knew where to find all these creatures and would gather them up and place them in a warm cardboard box for the night, making sure they were well fed. When morning came he would release them back into the air. This went on every day, and the birds became accustomed to his kindness.

Pierre was a kind and gentle man, full of compassion for others. Had he been on *Titanic*, Pierre would have been one of those helping people into the lifeboats.

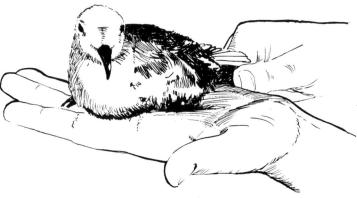

Unity within diversity

The days when Russia and the United States were playing cold war chess are gone, and the Soviet Union no longer exists as it did back in the sixties. A memento of this era, however, still lingers on board the *Keldysh* in the cabin of a crew member in the form of a flag with the hammer and sickle. It made me quite conscious that I was not only a guest of the Americans who had hired the *Keldysh* but of the Russians and their country.

Being on a Russian ship in the middle of the Atlantic Ocean in an exchange of friendship and commerce was beyond imagination when I was growing up during the Cold War. In general, I think populations of countries have never had a problem getting along. It's always politicians and leaders who find ways to draw the people into concentrating on differences. It usually has its beginnings with outer things like oil and land but is really about power and greed to benefit only a few.

Diversity among people shouldn't be a cause of prejudice but often is. I think it's important for countries to preserve their own heritage and diversity, but it should always serve to add richness to everyone's life, not be the cause of disparity. Two quotes I am fond of from the Bahá'i faith read, "The earth is but one country and mankind its citizens" and "Ye are all the flowers of one garden." Being on board the ship made me feel very aware of these teachings.

Chief Mate Alexi and his son, who was a Merchant Marine Naval cadet.

A young Russian member of the deck force on board the Keldysh.

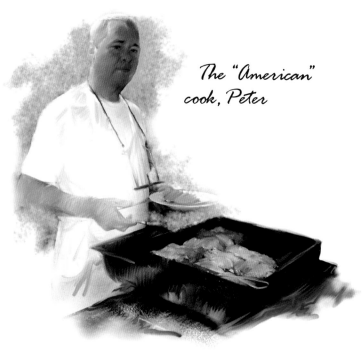

The "American" cook, Peter

If you had been sailing first class on *Titanic* the night it sank, these would have been the items on your dinner menu:

- Shrimp canapés and raw oysters with vodka, lemon, and hot sauce
- Consommé Olga cream of barley
- Poached salmon with mousseline sauce
- A choice of filet mignon with foie gras and black truffles or sauté of chicken Lyonnaise, plus a stuffed zucchinilike vegetable
- A choice of minted lamb, glazed roast duckling or beef sirloin, served with Chateau potatoes, mint pea timbales and creamed carrots
- Salmon, mousseline Sauce, cucumber
- Vegetable marrow farcie
- Applesauce
- Boiled rice
- Parmentier & boiled new potatoes
- Punch romaine
- Celery
- A palate-clearing sorbet made from champagne, orange juice, and rum
- Roast squab on watercress
- Asparagus-champagne-saffron salad
- A cold plate, including paté de foie gras
- A choice of desserts, including peaches jellied in Chartreuse liqueur, chocolate and vanilla éclairs, Waldorf pudding, French vanilla ice cream
- Assorted fresh fruits and cheeses

Dining over *Titanic*

Having gotten over being seasick, I found that mealtime had once again become a pleasure. The food on board the *Keldysh* was simple and good and had more than a hint of Russian influence to it. Lots of delicious soups.

The ship had two dining areas, and the kitchen was situated between them. One side was for the Russians and the other for the Americans. I would have preferred being able to eat all together in a group. It would have been more interesting, but the Russians either didn't want to or felt that we didn't want to. Of course, our cultures have different tastes, and the ship tried to accommodate everyone by serving each side a different menu. They did a pretty good job. I greatly enjoyed every meal.

The Americans had brought their own cook along but the Russian influence still came through. I think much of what we had was determined simply by what our cook had to work with and the type of food brought on board. The other factor was that our "American" cook was not American. He was from Austria, and even though he had been in the United States for nine years, his Austrian influence was evident in his dishes.

His name was Peter, which he pronounced as "Pee-taah." He roomed next to me, and when we would open up the door between our rooms, enormous clouds of cigarette smoke would bellow in. You would think the ship was on fire. I had no idea how he could even taste his own cooking because all the taste buds in his mouth must have long been destroyed. Steve, who roomed with Peter, somehow managed to live in the cloud.

Here's one of our more elegant dinners. As you see, this one included the great Russian treat, caviar.

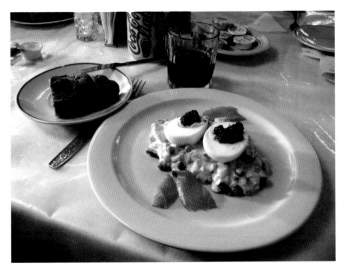

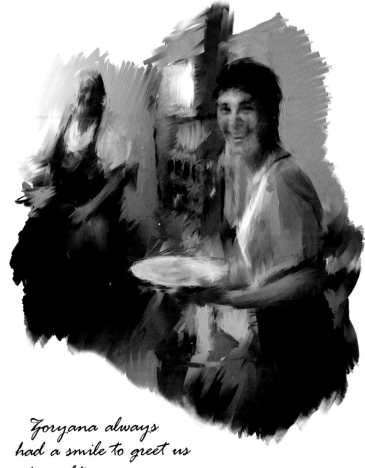

Zoryana always had a smile to greet us at mealtime.

One of our Russian waitresses on board the *Keldysh* was named Zoryana. Just to show you how unequal opportunities still exist, one of our other waitresses, named Irena, had a background working as a professor of literature at a Russian university—vastly overqualified to be serving us dinner. She is certainly more qualified than I am to write a journal about the expedition, but opportunities that translate into a livelihood are just not as available in Russia as in the United States.

The financial rewards for Zoryana were better for working on the *Keldysh* than for teaching, even though each worked for only five U.S. dollars a day, plus 1,600 Russian rubles per month (about $50) sent back to an account in Russia.

You would never know by their attitudes how meager the Russians' salaries were. While I was on the *Keldysh*, I didn't know how little they earned, but I never felt resentment from any of the Russians. It could be they see we're no happier or better off spiritually than they are. I've had several dear Russian friends, and I know the Russians are a rugged and persevering group of people because of their hardships. I admire their fortitude. We Americans are very soft compared to them. Knowing what I know now about Zoryana and Irena, I realize that I should have been waiting on them. The same goes for many others of the Russian crew who are brilliant and dedicated people.

Two of the chefs on board the Keldysh

Dive day

For days I had watched the submersibles go down to the *Titanic* and then return late in the day, bringing treasures to the surface. We didn't know from day to day who would be chosen to dive. For some reason still not clear to me, the information about the upcoming dives was kept secret. There was no schedule posted, and no one in authority knew or would admit who was going to dive and who was not. I assume politics were at work somewhere in the background, not with the Russians but with the Americans.

Certain people knew from the outset they weren't going to be able to dive. Among them were some of the television reporters and medical personnel. Others, like Lowell and myself, were told before we left Florida that we would dive, but there was always a question in our minds if we would, especially after being held over in St. John's.

When we arrived over *Titanic* there were only ten dives left. Lowell and I knew we were at the bottom of the barrel when it came to getting the opportunity to dive–and rightly so. Many others on board were either more qualified or simply had more authority.

The submersibles each held three people. One spot was for the command pilot and the second for someone who knew how to operate the cameras and act as copilot. That left only one place for a guest like myself.

With only two diving days left, I was told late in the evening I would be going down in the morning—followed by a "probably, but we're not sure yet." This ping-pong emotional ride continued all evening. I would first be assured I would dive, and then again I would be told, "We're not sure." I finally went to bed later in the

evening after reading some Bahá'i prayers. Whatever happened would be OK.

The word came early the next morning as a knock on my cabin door. I was on the list. I had a light breakfast and made sure I didn't drink too much. Soon I would be climbing the ladder into the *Mir* and descending into the depths for a visit to a museum that few people will ever see.

After finishing breakfast, I gathered my cameras, checked my batteries, and basically paced around the deck. Topside, a flurry of activity was already taking place. Boat launching and readying of the *Mir* was being attended to. While this was going on, I was given a blue,

flameproof, Nomex suit. There were only a few of these uniforms on the ship and they all had a name sewn onto them above the pocket signifying its wearer. I was handed a roll of white medical adhesive tape and a felt pen to make my own personal name patch. Knowing I was quite handy as a sign painter, the others had had me doing their tags for the past several dives. I made mine to look like an official military-type stencil. I plastered it over the existing name on the uniform and felt official.

My "official" name patch, made from medical adhesive tape:

R.L. BANSEMER

Lowell took my video camera and followed me around the ship and down the passageways, recording my nervous pacings. I was like someone not wanting to be late for an appointment.

We entered the Submersible Operations Room, where submersible pilots had already gathered. My bag with camera gear and other belongings was inspected and weighed as I was motioned over to the table where "Mama Bubushka" had me sign the dive protocol, which stated the conditions of the various systems on the sub and listed me as a crew member. Of course, at the time I was putting my signature to all the papers I didn't have the slightest clue about what I was signing. All I knew was in the next few minutes I would be locked inside the *Mir* and on my way to see the *Titanic*.

Many of the Russians on the ship had nicknames given to them by the guests, and Mama Bubushka was no exception. None of them were mean or harmful, but rather meant to be affectionate. I'm sure the Russians must have given us all nicknames as well, and it would have been interesting to know what some of them were.

I was surprised to see her in the room because there were lots of cameras and people taking pictures. Ever since I had been on the ship, as soon as she would pick up the scent of a camera she would quickly turn away and head off in a different direction. Since being here during the pre-dive operations was one of her duties, she just put up with it. She had a wonderfully weathered face and would have been a great subject had she been more available. I managed to capture a picture of her only once on deck.

The operations room was now a flurry of excitement, everyone talking at the same time, and the noise level way above what I am used to. The pilots of the *Mir*s had charts on the wall and were discussing in Russian the details and sequence of events for a successful dive. We were finally called to attention and let in on some of the conversation as the head of the *Mir* Group, Anatoly Sagalevitch, spoke in English. I listened intently but didn't hear one single word. My emotions were at such a high pitch it all went right past me. If he had said the water-tight hatch had just been replaced with a new screen door and as soon as we hit the water we would sink like a stone and never come up, I would have been just smiling and nodding my head. OK, let's do it!

When the formalities were over, the door to the deck was opened. The bright morning light flooded in as we filed out to where I assumed I would then climb up the ladder and into the submersible.

The elusive "Mama Babushka" did everything she could to keep out of the camera's eye.

Victor, one of the pilots, was pensive and thoughtful instead of excited.

In the background

The ship's launch, named the *Koresh*, meaning friendship, had been hoisted into the water during the briefing. Its job is to tow the submersibles away from the *Keldysh* and into the correct position over the *Titanic*—usually a few hundred yards away—so when they reach the bottom they will be close to the right spot—near *Titanic* but not on top of it.

Lots of activities take place during the launching of the subs, all carried out by the Russian crew. This inflatable, along with the Koresh, played a large part.

The Koresh was the workhorse for the Keldysh and was used to tow the subs away from the ship after they were launched. ↓

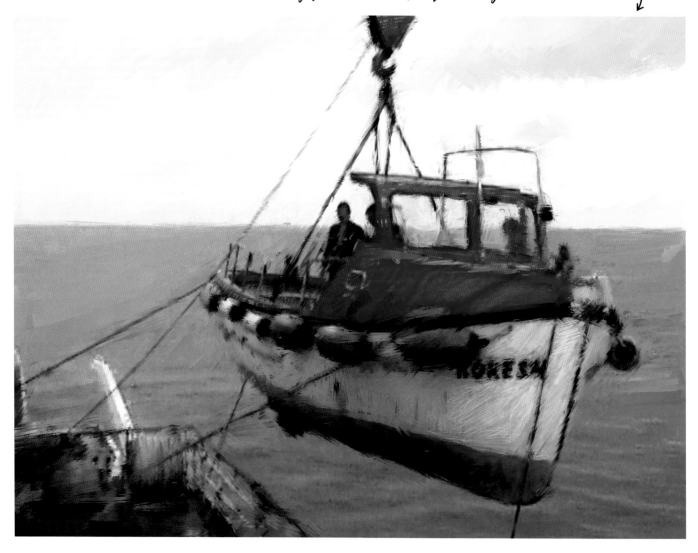

The Koresh waits in the water as the submersibles are being launched. Soon it will tow them to the drop site.

There are three men monitoring the subs constantly from the time they hit the water until they return back to the ship. From the Sub Plot Room, their job is to keep in constant communication and track the *Mir*s' every move. They do this with four, sometimes five, transponders that have previously been deployed. The transponders are suspended about three hundred feet off the ocean floor in as close to a rectangle as possible around the *Titanic*. They put out radio signals, as do the subs, and triangulating the coordinates from these fixed points gives an accurate picture of where the subs are located and in which direction they're moving.

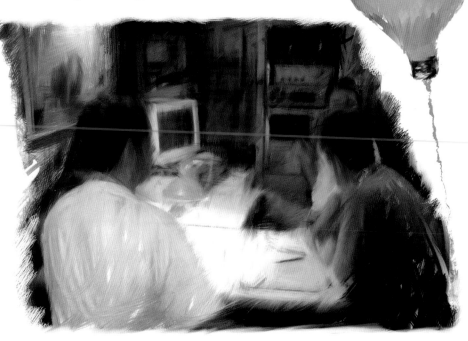

This is one of the transponders giving off signals that tell the submersibles and trackers exactly where the submersibles are.

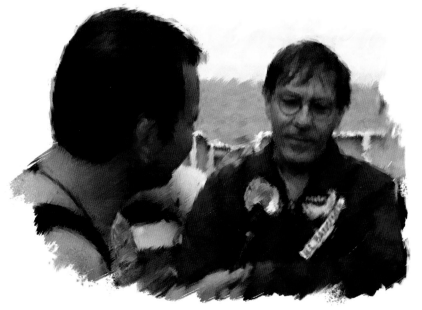

Petrik, who was the official videographer for the expedition, also asked me to sit down and talk about what I was feeling.

All I could really think about was getting over to where the *Mir* was being prepared. Listening to myself talk was the last thing I wanted to do, but I was on automatic, so I babbled in front of the camera a bit about things I hoped might sound good for an interview.

I hadn't analyzed my feelings about the dive. It wasn't like going into a football game with a strategy about what I was going to do or how I was going to win. I was a spectator in the bleachers and didn't know what to expect or exactly how to feel.

While I was being interviewed, cranes were lifting the Mirs' hydraulic canopies like large lids on two large lunchboxes.

Activity was already at a heightened pitch with the Russian crew attending to all the details concerning the launch. It took at least a dozen men to wrestle each *Mir* into the water.

Though I had already seen the *Mir*s launch for previous dives, I was eager to take in all of the activities once again for my dive. I was overtaken on my way to the *Mir* by television reporter Lloyd Sowers, who wanted an interview before I dove. Another cameraman, Nik

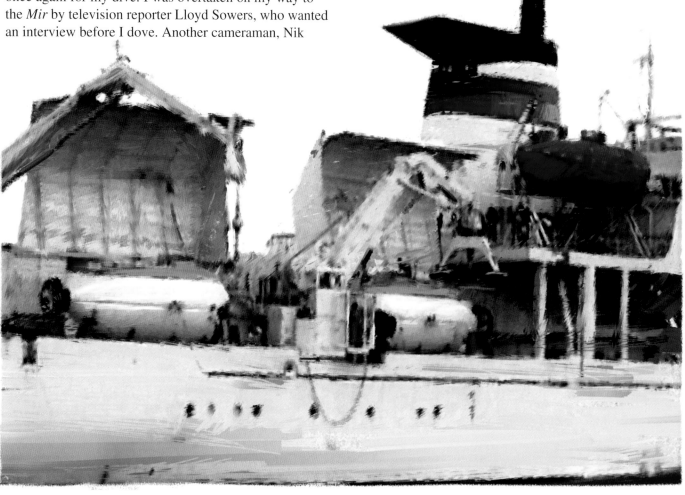

The launch sequence was busy and very noisy. Heavy cranes were in operation and orders were being shouted in every direction by the Russian technicians in charge.

Americans, English, Canadians, Irish, and I'm sure other nationalities I wasn't aware of were all part of the expedition, and everyone showed up for the morning's excitement.

The Russian crew took a less enthusiastic view of a launch since they have seen it so many times that it has become commonplace. But, as activity is always more interesting than no goings-on at all, the ones not directly involved in the launch also came out for a look if they could break away from their other duties.

The Russians working on getting the subs into the water were very tolerant and somehow put up with everyone crowding around for a better look. There was no policing of anyone to stay away from the machinery and launch procedure. No doubt that made it dangerous, but it *was* great excitement.

We had all been informed that being out here on this expedition was hazardous and something terrible could possibly happen to any one of us at any time. It was not a luxury cruise. The freedom to wander about during all the activity was a real plus, and I know everyone, with maybe the exception of the Russians trying to work, enjoyed the lack of restrictions.

Being in the middle of it all, I *really* had no idea of what was going on around me. I was in a daze. The interview ended and I was escorted over to the sub. All of a sudden this machine I was about to enter seemed alive and much larger than it had earlier when I was an onlooker. My point of view changed dramatically from third person to first person. Towering over me, it was no longer just a shape of orange and white but had become a breathing whale of awesome capacity whose stomach I was about to enter. I came to a full realization it was something special.

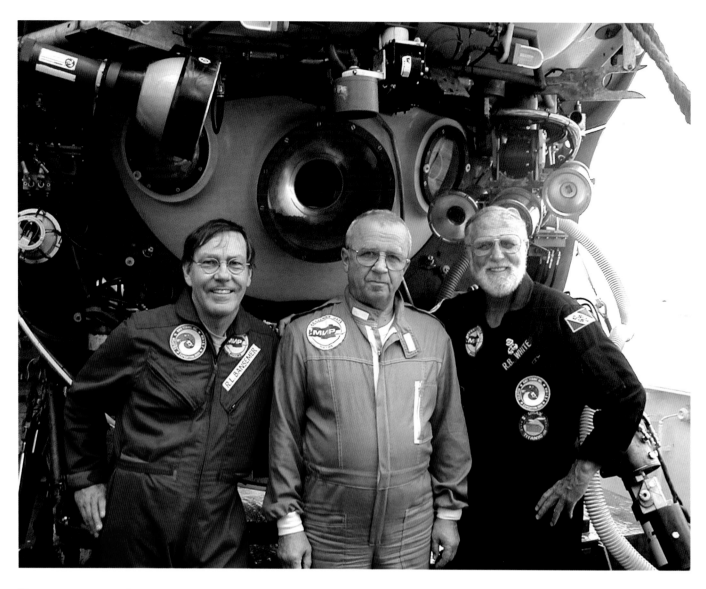

Prepare to dive

Of the thousands of pictures I took during my expedition both on board the *Keldysh* and in the *Mir*, this is my favorite. It's as close as I'll ever get to my equivalent of three astronauts about to go to the moon. That comparison, I was to find out, was not very far off the mark.

The crew consisted of two experts who have been down to the *Titanic* many times and myself. I'm on the left with a large smile; the Russian pilot, Anatoly Sagalevitch, is in the center with a look of "Do we have to do this photo thing every time?"; and copilot Ralph White is on the right. This would be Ralph's thirty-third dive to *Titanic*, more than any other American in history. He has that "I'm ready to dive anytime" look.

This was an extraordinary moment. It's so difficult to remember all the emotions of anticipation that were going through my mind, and I don't want to pretend this was a lighthearted moment. Shortly we would be

severed from the upper world and drop to where *Titanic* and all her secrets rest.

Less than two weeks before I hadn't had so much as a thought I would be here and about to descend in a Russian submersible two and a half miles below the surface of the ocean. In fact, I had been sitting around my studio wondering what my next project for a book might be. Hundreds of thousands, maybe millions, of people would love to have taken my place at this moment standing here in front of the *Mir,* but here I was, Roger Bansemer from Clearwater, Florida, about to make the trip. It was very strange!

Occasionally good things happen to us all. The best thing to do when that time comes is be thankful and accept it, and I certainly did.

Entering the Mir for the dive to Titanic

For days I had been on the outside watching others enter the submersibles in the mornings and return late in the day with treasures from *Titanic*. Now it was my turn.

Ralph was the first to enter. I was next in line to climb up the flimsy aluminum ladder. It was built with a curve to fit around the sub, but it felt extremely insubstantial as I climbed. During the twenty-foot climb to the top, it felt like it would collapse at any moment. I could just picture myself falling, getting hurt, and not being able to go on the dive. But after taking some carefully placed footsteps, I successfully made it to the top.

There I was met by one of the Russian technicians. He had a plastic milk crate, the type delivery men use to hold a half dozen milk containers and college students use to build book cases. He motioned for me to place my tennis shoes in it.

I had brought a pair of slippers along that my mom had knit for me before I left home, and I would use them to keep my feet warm once inside.

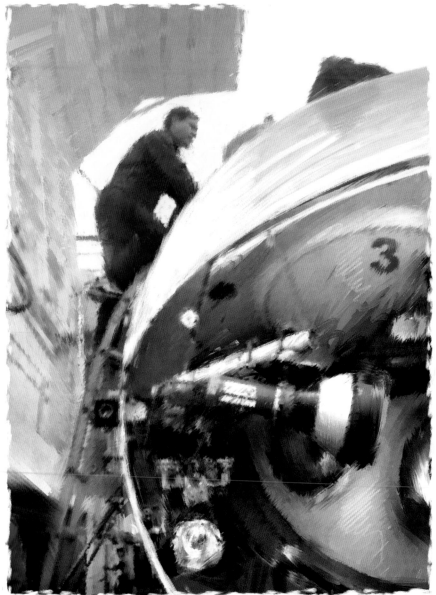

No shoes were allowed in the sub for the obvious reason that some electronic equipment might be accidently kicked, but there were other more important reasons for leaving the shoes behind. As someone walks around the deck, his shoes pick up a lot of oil and hydraulic fluids on the soles. Just the trace residue of those chemicals in the hundred-percent oxygen atmosphere inside the sub could cause spontaneous combustion and engulf everyone in flames. It would be similar to what happened in Apollo One when astronauts Gus Grissom, Edward H. White II, and Roger B. Chaffee died in their capsule during a launch pad test back in 1967. In their case it was an oily residue in the wiring insulation that caused the fire, but our oily shoes would have had the same result.

With my forty-dollar tennis shoes safely left behind in the plastic milk crate, I began my descent into the twenty-million-dollar sub. The hatch was narrower than I had imagined, and I positioned myself over the opening and began to slowly descend, taking care not to fall straight down inside the *Mir*.

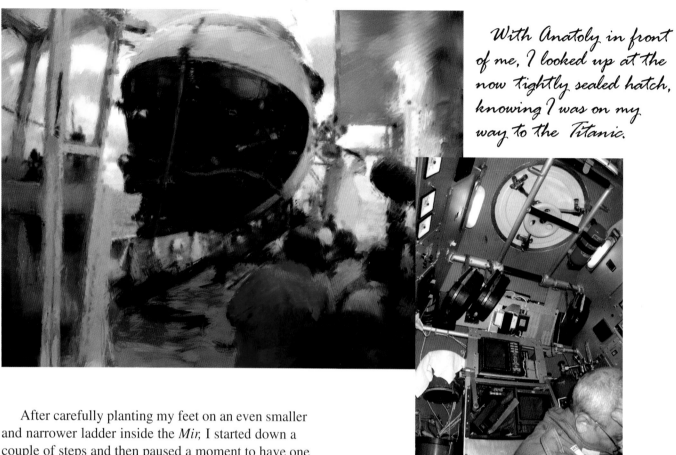

After carefully planting my feet on an even smaller and narrower ladder inside the *Mir,* I started down a couple of steps and then paused a moment to have one last look at everyone looking back at me. It was kind of a last salute to the world before going "where no man had gone before" (well, very few men, anyway). I gave a wave, as customary, followed by a peace sign—and felt silly for having done something that had fallen out of fashion since the sixties. I then disappeared inside the *Mir,* followed by Anatoly. Making it down these last few rungs meant that I would be on my way, barring any mechanical problems. The hatch was dogged down behind us and at that point I knew there was no turning back. Of course, turning back was the last thing I wanted.

I didn't know in the slightest what to expect during the dive. All I knew was when the hatch closed there were no longer any more days of wondering if I would be diving or not. I was here, sealed in this strange metallic environment for the duration of the day. I could tell in the first few minutes that it wouldn't be a quiet journey. Communications with the *Keldysh* were already taking place and the "squawk box" mounted on my left was producing constant static with interruptions of Russian voices talking back and forth about things I will never know.

I was a fish out of water but I did my best to settle in, be quiet, and let Anatoly and Ralph tend to their chores. There were actually no instructions about what to do at this time. I was to be on the starboard bench. That's it. I could either sit up or lie down. Since I could only see out

of the tiny viewport by lying down, and was eager to see all I could even if it was just the outside from where I had just come, I positioned myself prone and pressed my face against the pane.

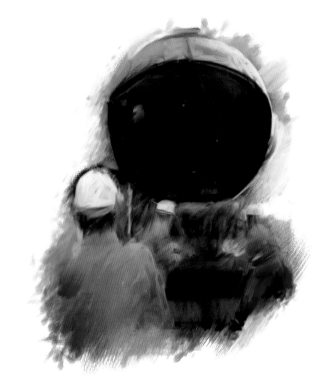

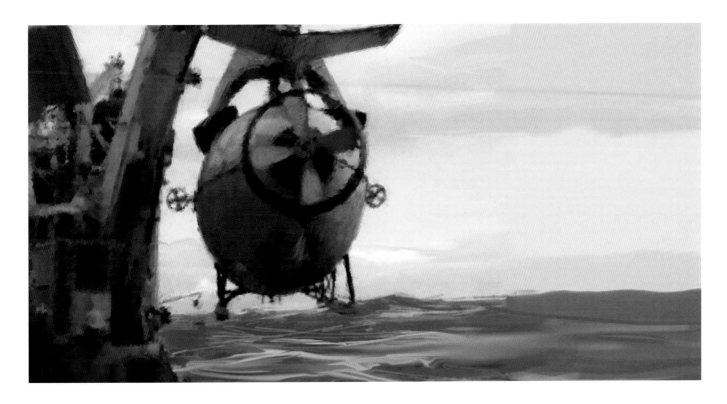

Over the side

There were two submersibles on board the *Keldysh* and both were being launched, one after the other. Although my field of vision was limited, I could see the Russian crew working in their orange jumpsuits, holding lines to keep the twenty-ton sub from bumping into anything upon being lifted. I felt a slight jolt from the hydraulic crane, and at that moment we rose off the deck. Lift-off!

Everyone crowded around the deck with their cameras as I had done in past days. Shortly we were swung over the side and I could see the *Keldysh* reflecting itself in the blue water. After a few more sudden motions, like the movement of a Ferris wheel that had just started, we were lowered into the cold Atlantic waters.

Everything from here on out was in someone else's hands, certainly not in mine. There were Anatoly and Ralph, and there was the crew of the *Keldysh* that would be monitoring us, and I was certainly hoping God would be acting as our main pilot or at least be along for the ride. Locked inside, Ralph and Anatoly continued to do their pre-dive checks on gauges that were a total mystery to me.

Inside the sub was a strange and foreign environment that would be my home for the next thirteen and a half hours. In moments the daylight would

disappear, and in a couple of hours I would be getting my first glimpse of the *Titanic*. The second the hatch closed, I knew I was somewhere I didn't really deserve to be but for the generosity of an old friend who suggested that I be brought along and a few new friends who seemed to think that I could make something of being here.

Lots of thoughts were going through my head as the sub was being hoisted over the side, into the water, and towed away from the ship, but mostly I had feelings of insignificance and disbelief.

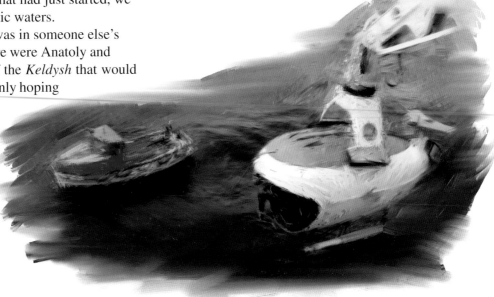

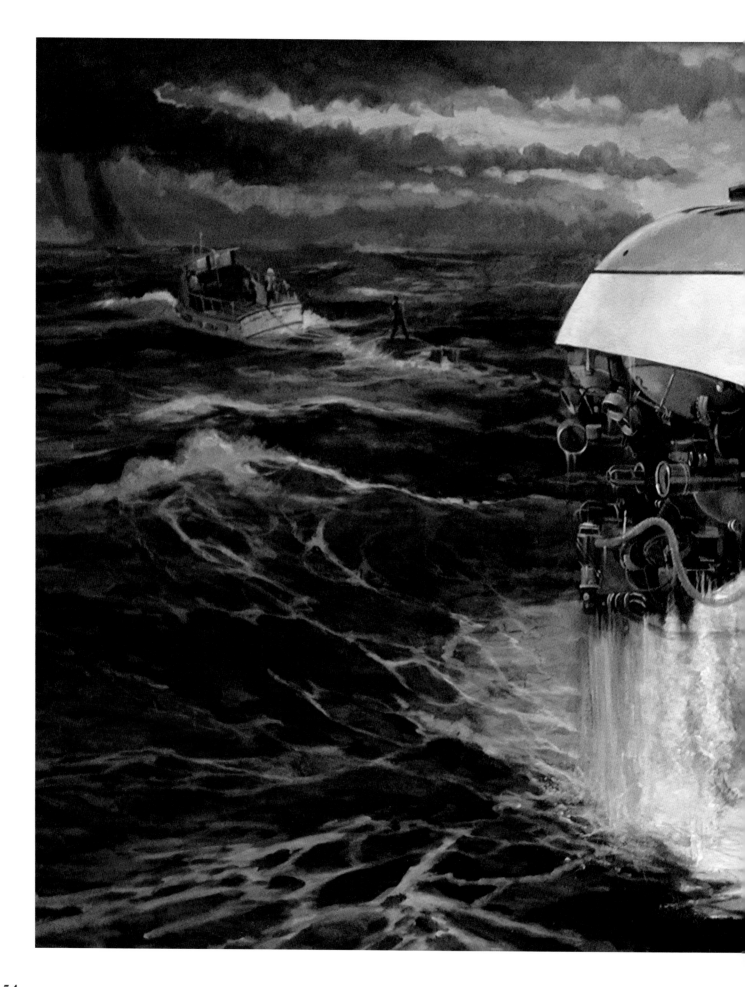

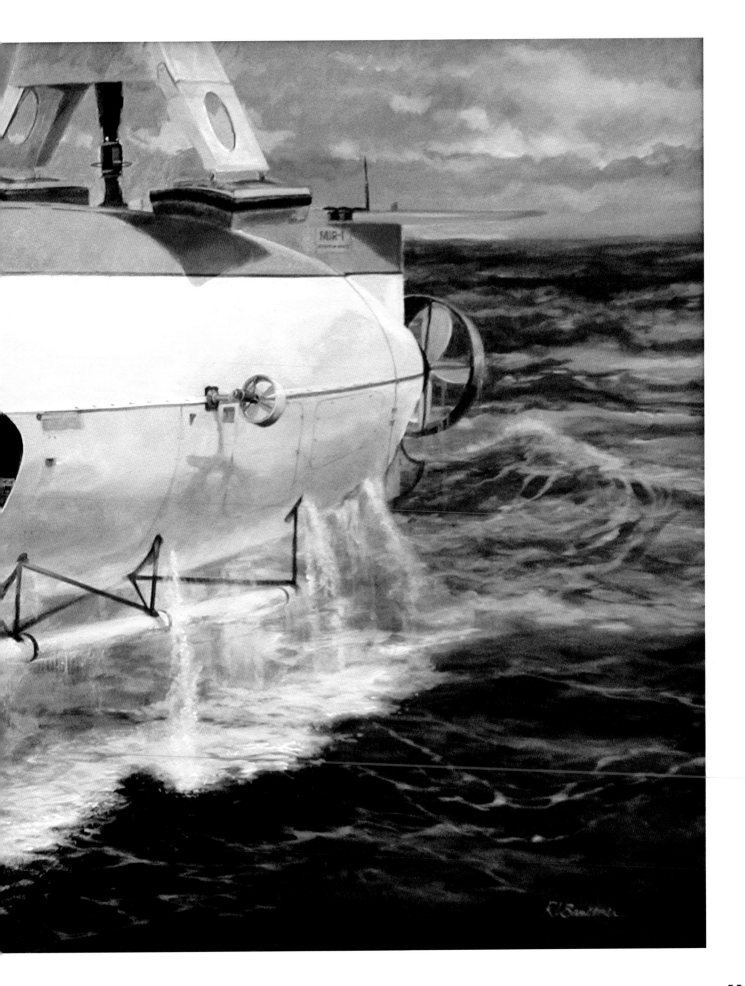

Everyone tries to find that one great spot
from which to watch the launching of the
Miss. A vantage point right below the
lifeboat offered one such place. It made an
interesting design against the blue sky.

As the submersible was lowered into the water I knew the importance of what was being done and at what expense. This trip was coach but definitely not economy.

More than $5,500,000 was being spent on the expedition, and a total of twenty-eight dives were made. That comes to a cost of $196,428 per dive. Each dive lasts about twelve hours, so breaking it down a bit further, that comes to $16,370 an hour, or $273 a minute, or $4.55 a second. Since there were two submersibles and both went down at the same time, these numbers could be doubled for the total cost of dives made in one day.

Being a guest on board the *Keldysh* was a privilege in its own right, but being able to take part in one of the dives and help retrieve artifacts was something only a few people have ever done. I was logged as being the 112th person to ever dive to the *Titanic*. More people have been in space.

As the excitement of the first few minutes passed inside the sub, outside, the entire ship was focused on getting us launched safely. The *Koresh* by this time had come up alongside the *Keldysh* as well as the inflatable.

My view of the crew and all their activity disappeared from sight as the *Mir* began to be lowered over the side.

We touched the water with a splash, and I saw the waves start lapping up against the small thick pane of acrylic called a viewport, a more accurate term than porthole because portholes generally have the ability to open, which submersibles and submarines don't find particularly useful. The viewport would be my only visual link to the outside world.

A moment later the ocean was above me by several feet, and only the top of the submersible was still floating above the surface.

The process

As soon as the *Mir* touched the water the inflatable boat came alongside and the so-called "cowboy" leaped from it onto the top of the *Mir*, where he unhooked the harness connecting the sub to the hydraulic crane. Waves can toss the submersible around like a cork, so speed is essential and the cowboy worked quickly to get the craft away from the side of the ship, where the two can easily collide. The inflatable moved away and waited while the cowboy tossed a line from the sub to our towboat, the *Koresh*. As soon as these two jobs were accomplished, the *Koresh* towed us out to the appropriate spot over the *Titanic*, not far from the ship.

During the entire time, the cowboy rode on top of the sub. I think the Americans gave him the nickname. "Cowboy" doesn't sound like a Russian thing, but the name certainly fits his job description.

Being towed away from the Keldysh to the drop zone

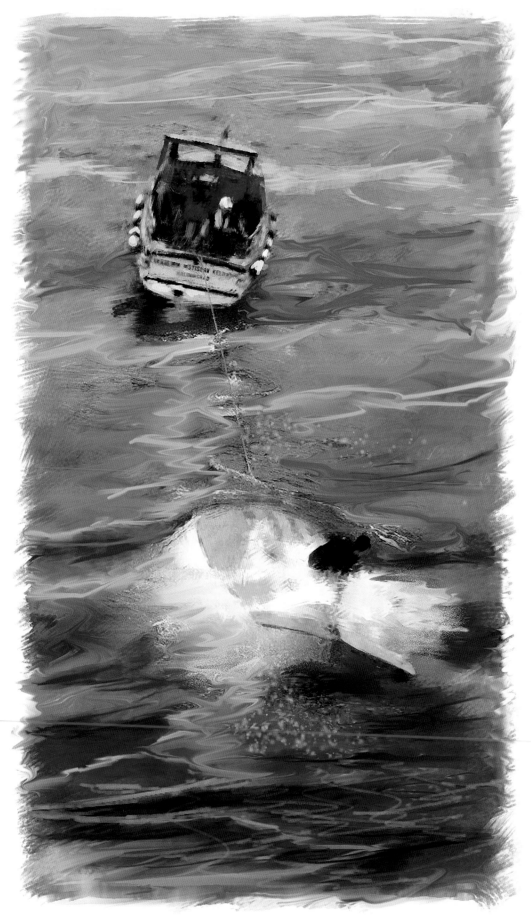

A few hundred yards from the Keldysh, we come to a spot over the Titanic where the Mir will be released.

The day outside was bright and sunny, but soon I would be heading for a place where no light from the surface penetrates except on these occasional visits by the submersibles. Each day before this I had been envious of those who were diving to the *Titanic,* but now I was in the envied position and everyone else was looking down from the ship, watching as I was leaving.

In spite of all the talk in days past about who was going to dive and who wasn't, it felt good to finally be inside the *Mir* and on my way. I had squeaked by all the politics and the who's who of diving priorities. It was dive number 13 for both *Mir I* and *Mir II* and turned out to be the next to the last dive made on the expedition.

Looking like a lonely, out-of-place, orange and white whale in the middle of the Atlantic, the Mir begins to fill its ballast tanks for its slow descent two and a half miles under the surface.

The sea was fairly calm. Swells of about six feet were rising and falling gently, but it wasn't choppy. Inside the *Mir* the motion was barely detectable. I could sense only a slight roll to one side then the other as we were being towed away from the ship and over to the drop zone.

The cowboy, who was still riding on top, untied the tow rope from the *Koresh,* and the inflatable once again came alongside the sub. His job done, the cowboy jumped into the inflatable and headed back to the ship. The sub sat quietly in the water for several minutes, continuing the process of filling the ballast tanks.

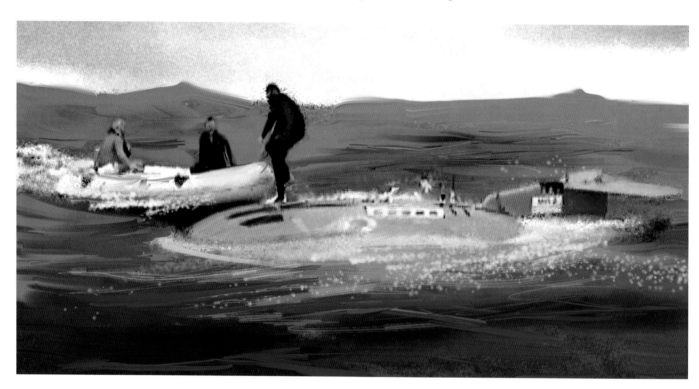

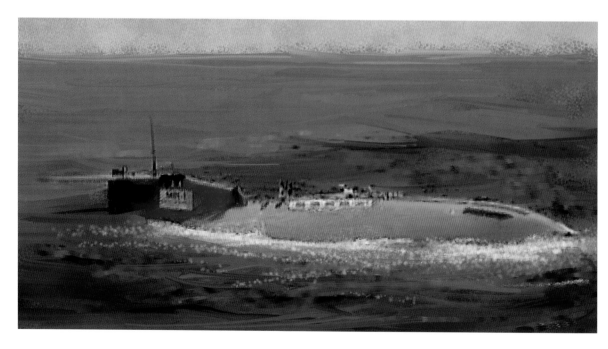

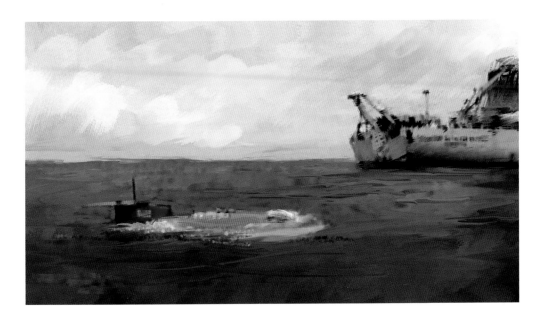

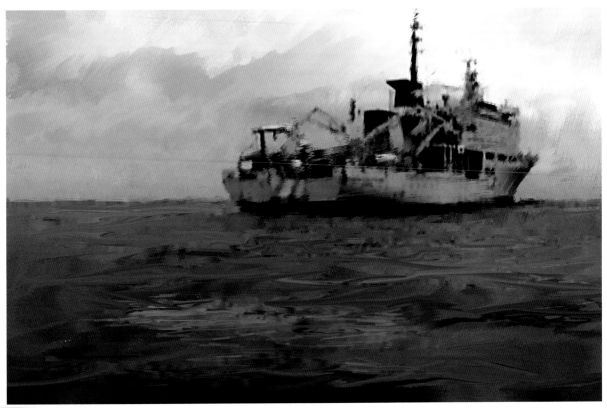

On the day before my dive I had gone out on the *Koresh* to watch Lowell go down in the sub. At almost an imperceptible rate it begins to descend, taking about ten minutes before it completely disappears from sight.

Emotional experiences are frequent out here and just knowing where the submersible was headed gave me an emotional jolt. Seeing the white hull turn to a beautiful robin-egg blue as it began its descent was something I will never forget. It was minutes before I could even speak to anyone.

Before I left home I had measured the distance of two and a half miles in my car as I drove across a long causeway from Clearwater to Tampa. I thought of that distance as the *Mir* began to descend.

Looking up from the small bench inside the *Mir*, I caught my last view of the waves as the surface of the water made diamond-shaped patterns above me then faded from sight as our descent began. The blue water turned to a dark green and then faded to black. We were on our way.

The pressure cooker

Inside, the submersible was cramped and hot. Ninety-five degrees hot. All that heat was generated by the submersible sitting on deck closed up like a car in a parking lot, with some additional heat generated by electronic equipment inside the *Mir*. Everything is kept closed as much as possible to keep out moisture, especially salt moisture.

The interior right from the start was sweaty, and the drops of water began to give us a light shower. I was told it would continue during the entire dive. There is an air conditioner on board, but it is not used during the dive as it would just increase the humidity.

Moments after being inside, we peeled away our jumpsuits to our waists. Anatoly handed me a towel supplied by *Mir*'s support crew to wipe away the sweat. As we began to descend, our cramped sphere started to cool and within a half hour became very comfortable as the outside water temperature dropped rapidly.

The 12,500-foot journey to the bottom takes about two hours. There isn't much to do for the next couple of hours. I asked about the gauges and switches, but mostly we all sat there quietly with our own thoughts. For a while Anatoly played a CD and we listened to classical music on what sounded like a two-inch speaker with the accompaniment of constant radio static from the communication link with the *Keldysh*. Since it was the only built-in creature comfort on board—everything else is strictly business—we enjoyed the CD player for what it was in order to pass the time.

A day to remember

Before I left home, I tried to think of small things to bring with me as mementos that I could say were at the *Titanic*. I can think of lots of things now, but before I left home I couldn't bring to mind anything. I did however manage to pack several special possessions, and I had placed them in my small duffle bag before boarding the *Mir*. I took along a small Bahá'í prayer book that was filled with the rose petals that I had picked in St. John's. I also had the book *A Night to Remember* by Walter Lord and a few music CDs, including the soundtrack from *Titanic*.

In my pocket I carried a small bolt that had been a part of the space shuttle. It was something that belonged to my daughter Lauren, and I brought it along at her suggestion. It may well be the first item to ever have been both at the *Titanic* and in outer space. In addition to those few items, I had pictures of my mom and dad; my wife, Sarah; and my children, Lauren and Rachael. I arranged those photographs above my viewport and snapped a few pictures of them lined up in a row. They remained there for part of the dive, but as moisture from our bodies continued to condensate on the walls of the sub, it became increasingly wet inside and the pictures began to stick to each other. I placed them back in my prayer book. Besides, I didn't want to make this incredible machine look too much like a college dorm room. It was just something that had meaning for me, so Anatoly and Ralph graciously put up with it without comment.

Ralph had a special dive stamp with an outline of the *Mir* on it followed by several lines where the longitude, latitude, depth, time, and date could be written. Then we all signed the items we brought with us. Ralph had commemorative letter envelopes, which we signed. He was kind enough to share a few with me.

The two-hour descent lent time for reflection and remembering loved ones.

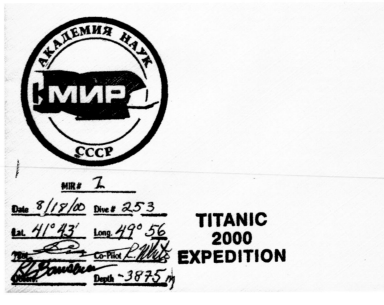

Dr. Anatoly Sagalevitch

When I dove to the *Titanic* I didn't fully realize the extraordinary company I was keeping. Anatoly, the Russian scientist with us, seemed to be a quiet sort, but I could tell that there was an incredible wealth of knowledge and curiosity within him. Among marine scientists, he is world renowned.

Before the dive, we hadn't had a lot of contact, but when he saw me on deck, he would sometimes put his hand on my shoulder for a second, just enough to let me know I was accepted in a small way into his larger world. I had brought along one of my earlier published lighthouse books, and it made the rounds among crew and guests. I wanted to bring more of my books, but as my camera and paint gear grew, the show-and-tell stuff diminished to just that one book. I signed it and gave it to Anatoly when the expedition was over.

I learned an important lesson one day when I interrupted him in his cabin. It was during a tense situation on board the ship that I wasn't aware of at the time. He stopped for a few minutes and selflessly allowed me to take some photos of him at his desk, all the time making me feel comfortable doing so. Only later did I find out that he was in the middle of much more important matters than looking down the lens of my camera just so I would have a few more pictures. Those small acts are far more memorable and meaningful than the larger gestures that are noticed by everyone.

As chief scientist and expedition leader on board the *Keldysh*, Anatoly had a major role in developing the design and workings of the submersibles. He has logged more than two thousand hours at a depth of over a mile and has authored six books and written 200 articles and scientific publications. Diving on *Titanic* is only a very small portion of what Anatoly has done. He is first of all a scientist and the *Titanic* takes a backseat to other more important activities that concern studies of the ocean. For the *Keldysh* and Anatoly, *Titanic* is an opportunity to hire out their very specialized and unique equipment, helping to subsidize other research all over the oceans of the world.

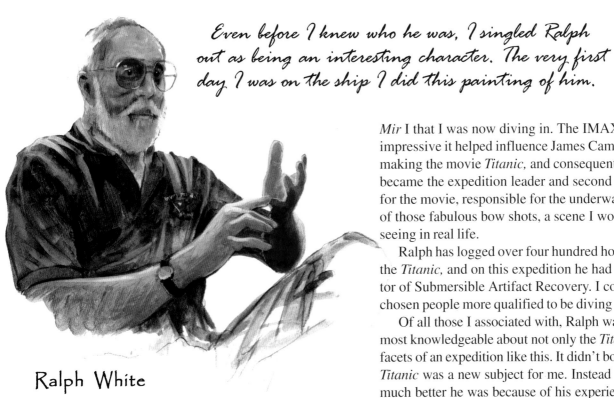

Even before I knew who he was, I singled Ralph out as being an interesting character. The very first day I was on the ship I did this painting of him.

Ralph White

Ralph has a rough-looking exterior, but as busy as he was during the expedition he was always friendly and ready to answer insignificant questions that I kept asking. Unlike Anatoly, Ralph is not the quiet sort. However, he is as much a legend as anyone on the planet when it comes to deep-sea diving and especially the *Titanic*.

Ralph's credentials are much thicker than this book, and although I'm usually not impressed with resumés, Ralph's work as cameraman and editor for films such as *The Deep*, *Into the Abyss*, and *Tora-Tora-Tora* impressed me.

He has also worked as cameraman for many television programs including *Wide World of Sports*. With more than thirty years of experience he has over four hundred television credits, many of which have been associated with National Geographic.

Diving is Ralph's speciality, but he is also a highly qualified helicopter pilot and astrovision aerial specialist and co-invented the bell camera helmet, which was first used in Ivan Tor's movie, *Ripcord*.

Parachuting is nothing new to Ralph as he has made more than 2,900 jumps, beginning in the Marine Corps when he served in—of all things—a parachute testing unit.

When it comes to diving on the *Titanic*, Ralph is the undisputed American title holder, having started in 1985 when it was discovered and having been on most of the expeditions since then. He helped to develop the deep ocean lighting and imaging systems used to photograph the *Titanic*. He also filmed the 70 mm IMAX movie *Titanica* for National Geographic. He's featured in much of the movie filmed in the very same Russian submersible

Mir I that I was now diving in. The IMAX film was so impressive it helped influence James Cameron into making the movie *Titanic,* and consequently Ralph became the expedition leader and second unit cameraman for the movie, responsible for the underwater photography of those fabulous bow shots, a scene I would shortly be seeing in real life.

Ralph has logged over four hundred hours exploring the *Titanic,* and on this expedition he had the title Director of Submersible Artifact Recovery. I couldn't have chosen people more qualified to be diving with.

Of all those I associated with, Ralph was by far the most knowledgeable about not only the *Titanic* but all the facets of an expedition like this. It didn't bother him that *Titanic* was a new subject for me. Instead of showing how much better he was because of his experiences, he made me feel at home and free to ask questions no matter how basic, sharing his knowledge selflessly. On board the *Keldysh*, his cabin was always open to everyone who wanted a few minutes of his time. More than all that, Ralph became a good friend.

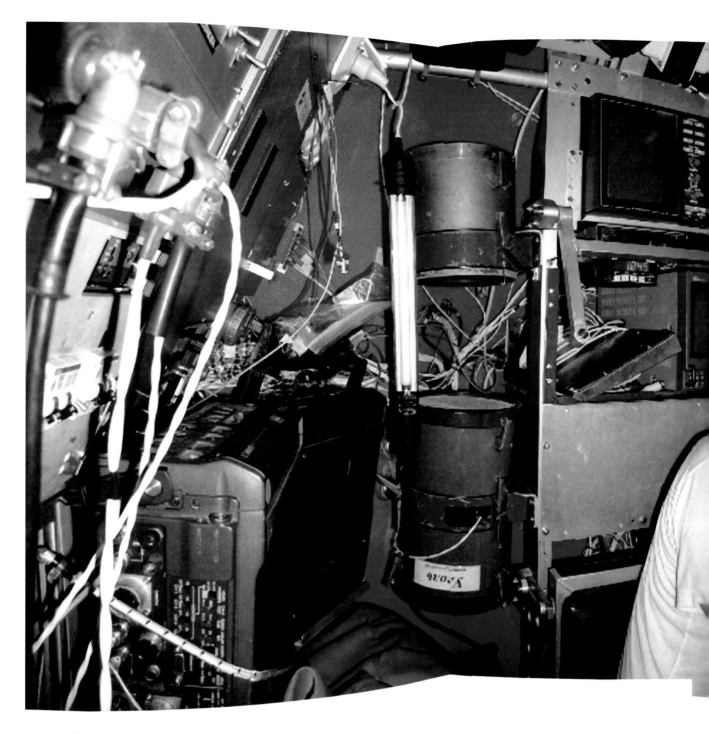

A tight fit

This is what it looks like inside the *Mir*, well almost. The picture makes it appear as if there is room enough to move around a bit. There isn't. Not even a little bit. As we were descending I took five photographs and later put them together to make this panoramic image. We still had our jumpsuits stripped down to our waists as the temperature inside was roasting.

The *Mir* was cramped, to say the least. It's not the place for someone who doesn't like small spaces. The three of us, like peas in a pod, shared this sphere measuring only 6.9 feet in diameter. Before I left Florida I was told

being in the sub would be like being inside an MRI at the hospital, and if I didn't find that idea appealing I shouldn't go. It wasn't quite that confining inside, but just about. Fortunately for me, any thoughts of claustrophobia were far outweighed by the anticipation of seeing the *Titanic*.

The blue jumpsuits we were wearing are made of a fire retardant material called Nomex. I flew hot-air balloons for many years and used to wear a similar jacket.

Since not enough air is inside the sub for the entire dive, a device called a "scrubber" removes the carbon dioxide, purifying the air for use over and over. Pure oxygen is also pumped into the cabin to supplement our

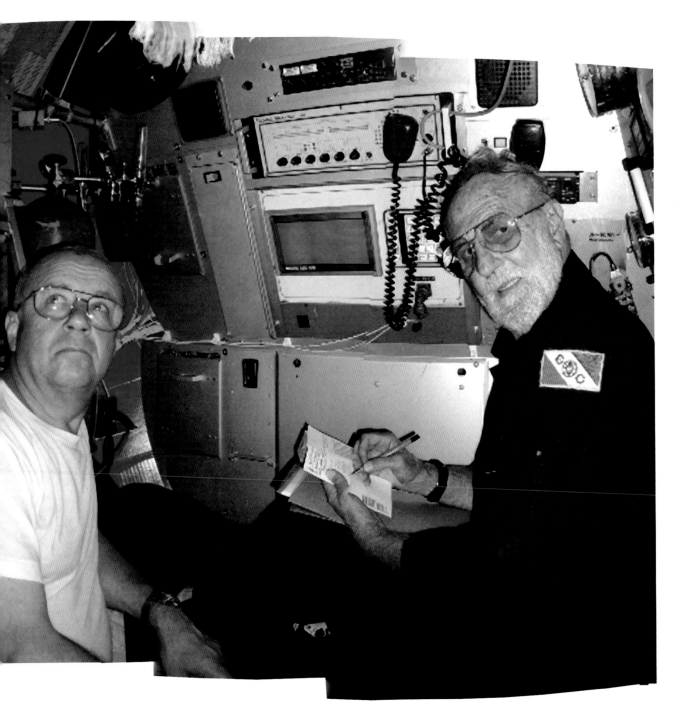

air supply, making it a somewhat hazardous environment. I was told the suit would help identify me if something were to happen, but I really didn't have any great fears. Any fear I did have concerned the oxygen-rich environment more than the tremendous pressure on the hull.

While I was thinking about our little self-contained environment, I inquired of Ralph how much time we could spend in the submersible before we ran out of air. Facts were always readily available from Ralph, and he instantly replied eighty-two hours, then told me not to worry as we would be dead of hypothermia long before our air would run out—a comforting thought.

Conversations with Anatoly were not as lively, but I asked how he came to help design the *Mir* and be one of its pilots. I never got much of an answer from him, but he paused for a moment, glanced at some instruments and simply said, "It's my life, that's all. It's just my life." A good Russian answer.

I did know he would have much preferred diving on something to do with marine research than the wreck of the *Titanic*. For Anatoly, there are too many wires and obstructions where we were going—too many places where the subs could actually get caught.

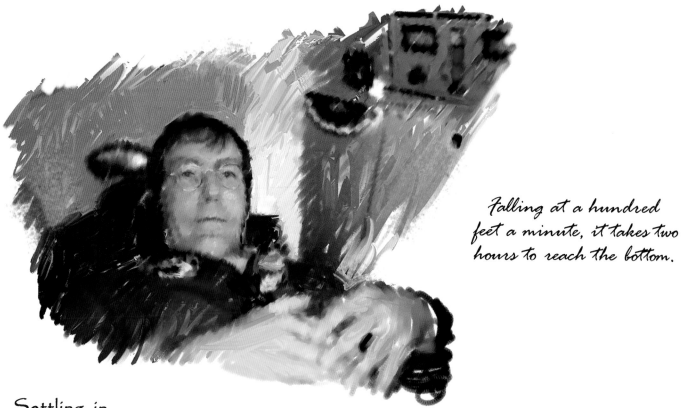

Falling at a hundred feet a minute, it takes two hours to reach the bottom.

Settling in

Everyone settled in and there was little for Ralph and Anatoly to attend to and nothing at all for me to do, so we lay quietly with our own thoughts. For them, being inside the *Mir* had become commonplace and, I think, may have been boring. For me, it was a new and exciting adventure

Anatoly had grown tired of his CD and turned it off. The only noise inside was the constant static and occasional Russian voice emanating from the speaker on the wall. I reached for the small duffle bag I'd tucked away near my feet and pulled out my CD player, plugged in my earphones, and listened to some of my own music.

I had no perception of movement. It felt like we were motionless in the water. In reality we were descending a hundred feet a minute. The stern was poised downward at a slight angle and we were spinning around on our own axis about every five minutes as we traveled towards the bottom.

Outside our cabin was total darkness. Every now and then the sub would let out a slight groan of complaint, a contraction of the metal due to the extreme pressure. No one seemed concerned. I had learned that if there were a breach in the hull of any sort, death would be so instantaneous— a matter of milliseconds— that we would never realize what happened and pleasantly wake up in the next world.

Reaching the bottom

As we went deeper and deeper the temperature of the water outside dropped to thirty-one degrees. Inside the temperature followed and slowly reached thirty-two degrees, where it stayed for the rest of the dive. Our submersible had become an ice cube in a large cup. The slippers my mom had knit came in handy. Ralph brought along his "moose slippers," which have seen *Titanic* many times. There is really nothing lighthearted about going down to the *Titanic,* and Ralph's slippers were more for comfort than comedy.

11:20 A.M.

Suddenly Anatoly snapped out of his apparent distant thoughts and began throwing switches. Ralph did the same. They were getting all the systems ready for our touchdown, performing maneuvers such as preparing for buoyancy and trim. That meant they were firing up the hydraulic pumps to begin pumping out seawater from the buoyancy tanks to make us neutrally buoyant—in other words, stop us from falling. The two small propellers mounted on the side of the *Mir,* called thrusters, were also turned facing down and revved up to slow our descent for a soft landing, hopefully not on the wreck itself.

Ralph was turning on the sonar and bottom profiler and began to pick up images of the ocean floor. At about six hundred feet he would try to locate exactly where we were by picking up any landmarks that might be in range. It was hard to believe what seemed to me like forty-five minutes had in fact been two hours.

The total blackness of the water outside our sphere was instantly transformed into a brilliant blue as Anatoly fired up the quartz lights.

Ralph's moose slippers

After having fallen in darkness for almost two hours, the Mir's exterior lights were turned on as we neared the bottom.

My first view of the ocean floor was like looking at the dark side of the moon.

Since this was my first real encounter with deep ocean diving, any little thing was totally fascinating to me. The first thing I noticed was the water. It was not crystal clear as I had expected but instead filled with small particles of everything organic and inorganic that gravity had eventually brought down from the miles of ocean above us, now suspended in the water column we also occupied. Called particulate matter, it was not so much a distraction to vision, just a revelation that so far down it would be present at all. And not only was it present, but in continual movement, noticeably stirred up by a very mild current.

Our destination was close at hand, but I still couldn't see the bottom even with my face pressed against the viewport. Ralph continued working with the sector scanning sonar trying to find a familiar landmark, but my concentration was centered totally outside—and then for the first time I was looking at the ocean floor.

As I lay on that flat bench, the entire population of earth was going about their business. More than six billion people were above me, and there was no living human being anywhere on earth close to being this far down at this moment except those of us in the *Mir*s. It may be a small claim to uniqueness, but for some reason it struck me.

11:24 A.M.

The moment of touchdown arrived. We gently made contact with the ocean floor two and a half miles below the surface without fanfare or incident. Some touchdowns, I was told, were rough with a hard hit on the bottom, but ours was not even noticeable. Anatoly, who had been sitting upright inside the *Mir*, got down on his knees where he would remain for the rest of the dive while maneuvering us around the ocean floor. From that position he would look out his viewport and use the instruments to slowly propel us about and also operate the joysticks to retrieve artifacts with the mechanical arms. Ralph, rather than looking out the viewport, looked towards the back of the *Mir*, where the television moni-

tors were mounted. He would be seeing the dive through the several cameras that he would be constantly operating.

So only two pairs of eyes were actually looking out on the scene, and though Ralph had the unique opportunity to use the cameras to zoom in and pan around a bit more than we did at the viewports, I was grateful to see directly into a world like none other.

Arriving at the bow

It took several minutes for Anatoly and Ralph to get their bearings, and in that time I got my first look around. I'm sure the ocean's bottom is quite varied around the world, but right where *Titanic* sank it is quite bland. It looked much like freshly poured plaster of Paris both in color and texture, smooth and with no sharp edges. In reality it is nothing like plaster but made up of very fine particles of sediment. Any movement of the submersible stirs it up in a huge cloud.

12:01 P.M.

For the past few minutes I had been looking at a totally barren ocean floor with the exception of some rocks of various sizes that have fallen from melting icebergs. Ralph told me a small crater around the rock would indicate it had been lying there for under a million years. Older rocks have had their craters filled and smoothed over at the rate of about one centimeter every thousand years. Any marks we would make on the bottom with our landing skids would also be as permanent.

Then the moment arrived. Suddenly and without warning, through the blueness of the water directly in front of us, the bow of the *Titanic* came into view. No one said a word. Anatoly and Ralph had seen it many times, but it was my first sight of *Titanic*. It was so spectacular I cannot begin to describe the feelings and emotions that rushed through me. It was almost like an electrical shock. I had no idea my first encounter with the ship would be the bow, but there it was, only ten or twelve yards away.

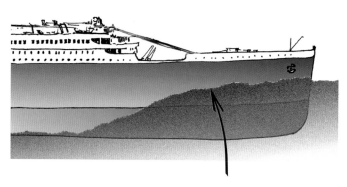

With its funnel torn away and its mast collapsed, the Titanic bow hit the bottom, plowing into the sediment at a forward angle. When it came to a stop, the back part fell, bringing it level.

The ship had driven itself more than sixty feet into the ocean floor when it hit, leaving only twenty-three feet of bow visible. As the ship broke apart and sank, the forward half of the ship went down bow first, at an angle and with a forward speed. That's why the bow and stern are some three quarters of a mile apart. As the bow hit the bottom and plowed itself into the sediment, it created a large berm that runs back about sixty feet.

I can only imagine the unspeakable crash there must have been for the huge ship to bury itself six stories into the sediment. This is especially true since only the top layer of sediment is soft. A few feet down it becomes like clay and very dense. It's a wonder that the bow remains intact at all and didn't fly apart at the seams when it hit. Despite all the speculation about iron and rivets being brittle and inferior, I think in many ways this is a tribute to the strength and craftsmanship of the *Titanic*.

Directly in front of the bow was a white starfish. I couldn't have possibly dreamed up my first encounter with the *Titanic* of the White Star Line with any more appropriate symbolism.

As we approached and traveled up the berm, a deep sea creature called a rattail leisurely swam by. It was rather large for a rattail, almost five feet in length. It paid us no attention, acting as if we were a frequent caller just dropping by for a visit. Oblivious of its prominent address, it staked out the bow as its personal territory. I later learned from Ralph that it's a longtime resident of *Titanic* and had the nickname of Sam. Smaller rattails that inhabited the area around the bow were called "sons of Sam."

I wasn't concentrating on science or marine biology as I was peering at this creature, but just so you know, rattails, or grenadier fish as they are sometimes called, are related to cod and are the most common fish at these depths in this area. They swim just above the bottom and eat live animals and carcasses.

The rattails have huge heads, large eyes, and long tapered tails. They slowly swim just above the bottom with the aid of a swim bladder that also gives them the ability to make sound, for what reason I have no idea. The large eyes fascinated me. Since it is totally dark at these depths, I wondered of what use eyes would be, but apparently there is enough light caused by bioluminescence in the water column for their specialized eyes to have some use. The Russians have been catching these fish to eat for many years.

We lingered a few moments before Anatoly maneuvered the sub up the knife edge of the bow ever so slowly. It was like rising up in a balloon, silently and effortlessly. The bow was no more than a few yards away.

The rattail was the largest deep sea creature I would see during my dive. "Sam," who lingered near the bow, was nearly five feet long.

As we ascended, the massive anchor came into view. It all happened too fast, and I wished we could have lingered much longer taking in this most awesome sight.

I was overwhelmed at the amount of rusticles that covered the hull. These fragile and hollow growths, which look like stalactites, are the result of iron-eating bacteria that live only at these depths. Year by year they continue to devour the ship and eventually will cover it entirely like a wild, out-of-control vine. The rusticles crumble at the slightest touch. Someday nothing will be left of *Titanic* but long strands of rust, and the hull will be nothing more than a huge heap of iron forming a large rust stain on the ocean's bottom.

Again, I wasn't thinking about what rusticles were made of while we were moving up the face of *Titanic*. Instead I was in total awe of seeing this ship in real life. I'm certain my mouth must have been open and my eyes large as headlights. I got an even better view as the *Mir* swung to the starboard side of the bow and crawled slowly upward. We were so close to the steel plates I was getting a good look at every rivet as we passed.

I was filled with questions and wanted everything explained. A running commentary would have been wonderful, but I refrained from asking much and let Ralph and Anatoly to do their jobs in peace.

Suddenly the eight-ton anchor appeared in my field of vision. Even had I been inclined to say anything, at that point it would have been impossible as I was speechless. I can look back on many things in life as being memorable even though at the time I didn't realize their importance, but this was a memorable moment and I knew it. This sight was an attention grabber of the first order. The idea of being within arm's reach of it seared into me. It may sound melodramatic, and though I'm not a historian who lives and breathes *Titanic*, it was overwhelming.

The anchor was heavily encrusted with rusticles and I'm sure in a decade it won't even be recognizable.

Titanic is not changeless and timeless by any means. Even after being there only a few minutes, I could tell it was different from photographs I had seen that were taken only a decade earlier. I was looking at a part of history that was reverting back into the elements of the earth at a rate even a novice like myself could comprehend. The cold water of the Atlantic at these depths is not preserving the ship, as some may think, but rather is quietly absorbing it.

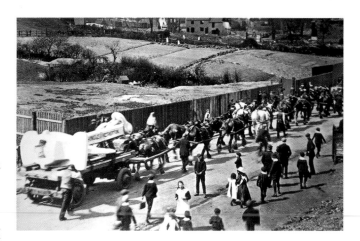

Titanic's center anchor weighted 50.5 tons and took 20 horses to pull it from the manufacturer to the railway station from which it was delivered to *Titanic*. It was much larger than the anchors on the side of the ship.

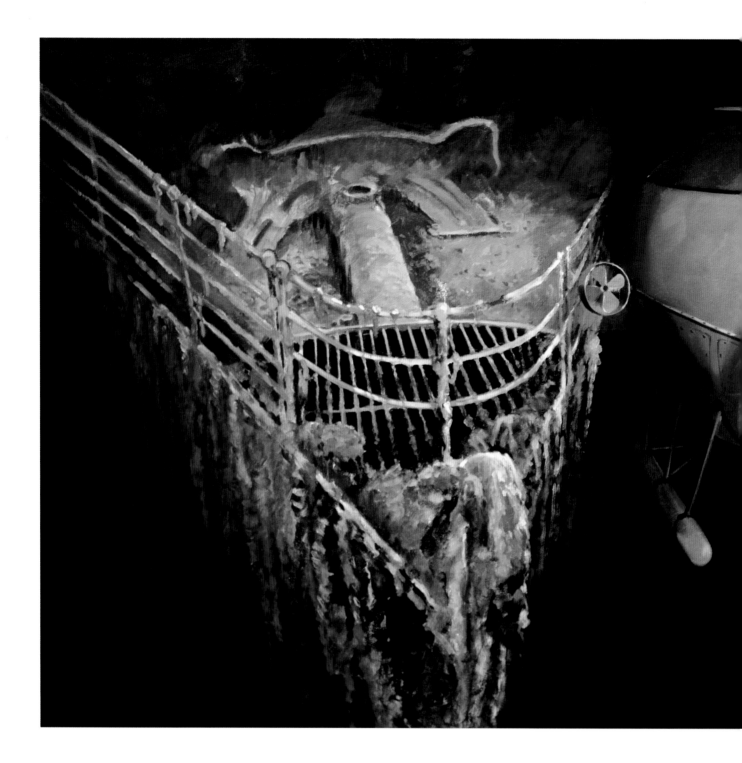

Anatoly then maneuvered the sub horizontally from the anchor back to the very bow of the ship, and we continued ascending. The sub became a bit parallel to the bow, and I lost sight of the ship for a moment. Then the sub turned just above the main deck, and in front of me the famous railings on the bow of *Titanic* came into view. I saw just a sliver at first, then as we turned the entire panorama of the bow came into sight.

Of all the views of the ship I would see that day, looking down at the bow of the *Titanic* and experiencing it full view surpassed all else in its power and effect on

me. It has probably become one of the most recognizable images in the world due in part to the scene in the movie when Leonard DiCaprio stands on the bow with out-stretched arms. A curious switch in thinking took place as I looked out my tiny viewport. It occurred to me how movies seem quite real while we sit in a darkened theater, yet actually being there *was* real but seemed unbelievable.

I also realized that not everyone who dove to *Titanic* got to see this magnificent view of the bow. The purpose of these expensive dives was not to give me or anyone else a tour of the ship. Ours was not a sight-seeing

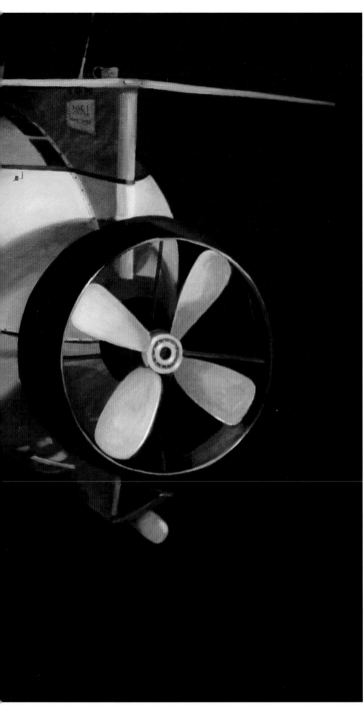

observer, but my expectations had been surpassed in the first few minutes. I was simply taking in whatever was offered me, and my plate was already overflowing.

With the exception of the ocean floor itself, all the colors were intense. The water appears a bright turquoise and slowly bleeds into the richest royal blue I have ever seen, finally fading off to black in the distance where the lights can no longer penetrate. No colors on my palette could come close to their brilliance. The bow of the ship was an array of burnt sienna, deep browns, ochres, and greens the color of weathered copper.

High intensity lights mounted on the front of the *Mir* in sophisticated underwater housings capable of withstanding the pressure were making these colors come alive. Some of the lights were on arms that swung out on each side of the *Mir*. The most powerful was a 1,200-watt halogen mercury light. Along with it were several 1,000-watt quartz lights and two iodine halide lamps that give off a green color but better penetrate the darkness. They were used when viewing but shut off when photographs were taken as they give pictures a sickly green hue. The eyes adjust to such things and I sensed no unpleasant color shifts when looking out my viewport. All these lights allowed us to see clearly to a distance of about forty feet, where objects finally faded away.

A view of the bow without Leonardo but with Sam the rattail instead.

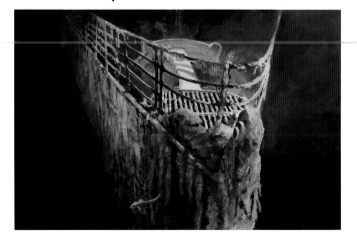

venture. We were there to retrieve artifacts, and every minute spent on the bow meant lost minutes in the debris field where artifacts could be found. On many of the dives, the *Mir*s didn't even go near the bow but instead straight to work in the debris field. I'm not sure how I became so fortunate to get this grand tour, but I wasn't about to question it.

Both Ralph and Anatoly knew that I intended to do a book about the experience, and maybe they took that into consideration. I had no input into what we would or wouldn't do and certainly wouldn't have been forward enough to request any special treatment. I was just the

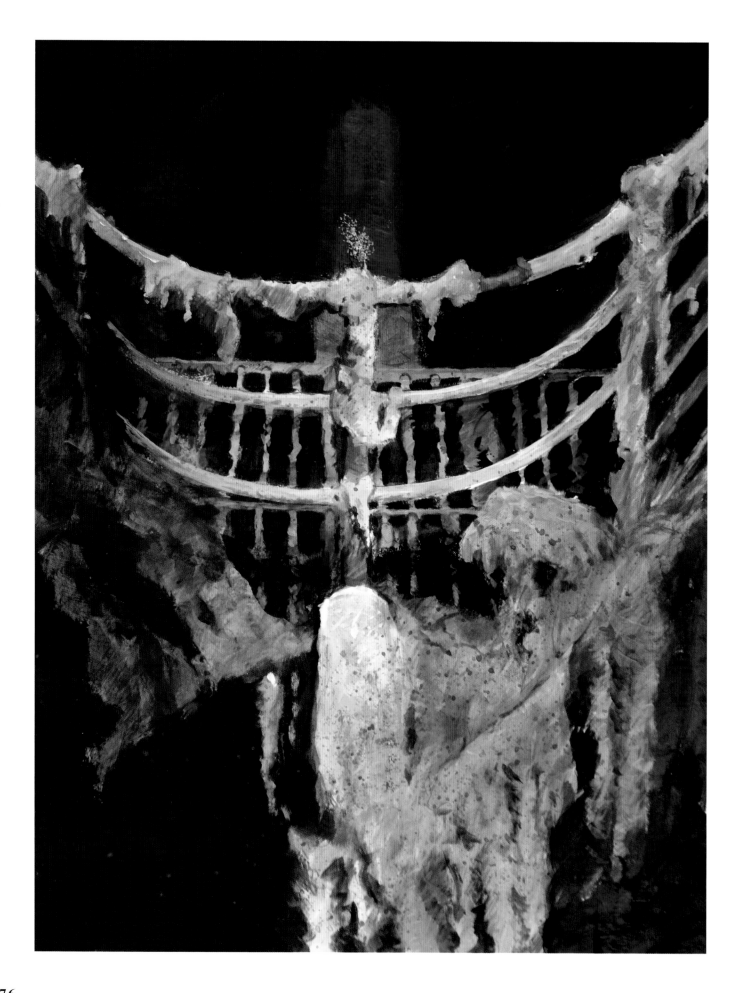

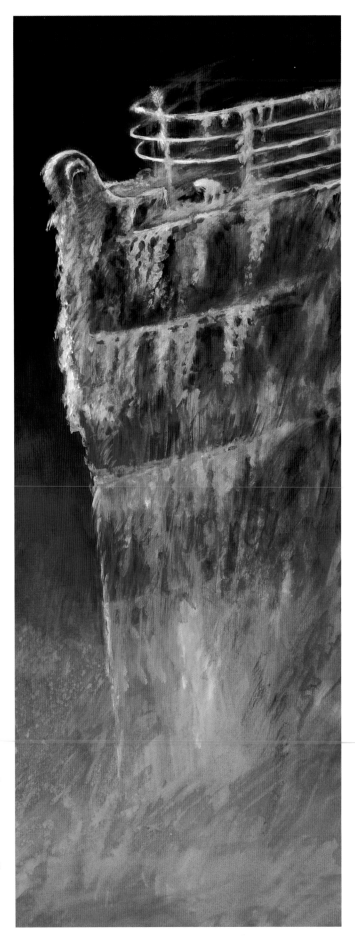

Spending time at the bow of Titanic was the most impressive part of the dive.

The grand tour

The submersible paused for a moment above the railing and it seemed to encapsulate in one view all the visions I had in my mind since boyhood about the *Titanic*. It has become a symbol of the great ship. The railings were intact and not covered with nearly as many rusticles as the hull. One small segment stood out with a bright rust color compared to the rest of the railing that took on a greenish-copper color. On the top railing at the very front of the ship was a cladorhiza sponge—like a living hood ornament placed there by Mother Nature. In a strange way this small and insignificant symbol seemed to claim the entire ship as its own. The deep ocean currents caused it to sway almost imperceptibly in contrast to the ship that has lain motionless for so many years.

Just in front of the railing I saw a large rounded decorative shape that looked, in earlier underwater photographs, like a towing bar of some sort, and I had seen a submersible moving up and down it in a video from a dive done back in the mid 1980s. In reality it was a heavy cable bridle with a one-inch guywire attached. It firmly secured the wire going to the top of the mast above the crow's nest and then back to the funnels (smoke stacks), continuing on to the back of the ship. The cable snapped when the ship broke apart, and the bridle flopped down in front of the bow. By the time of my dive, it had been welded in place and misshapen by rusticles and was a shadow of what I had seen in past images of it. It is another example of how the *Titanic* is quickly deteriorating.

The *Titanic* was made of iron, not steel. The rivets holding the ship together were also made of iron and of a lesser quality than the iron plates making up the side of the ship. The rusticles, I have been told, attack the iron of poorest quality first and thus start with the rivets. I'm sure many theories exist on all of this, but I do know had the *Titanic* been made of steel instead of iron, it would not be falling apart as quickly as it is.

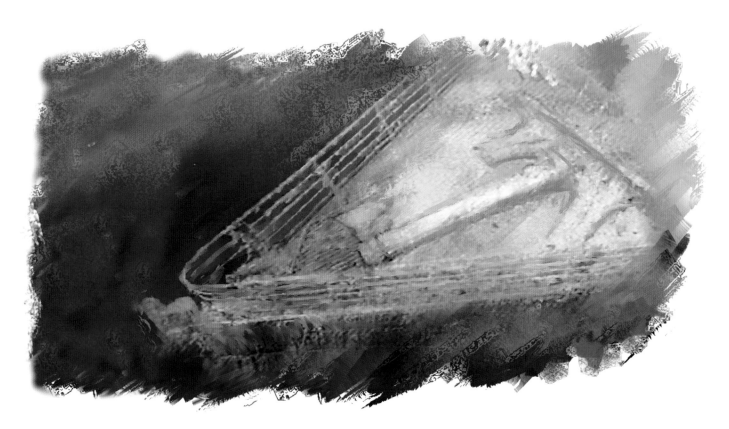

Anatoly touched the rear thruster control and the large propeller blade began to spin, slowly moving us ahead. He quickly took his hand from the button and the submersible continued forward on its own momentum. We drifted directly over the central anchor mounted on the deck just behind the bow. I pressed my face against the thick acrylic viewport in an effort to see it for as long as I could as we passed.

Of the three main anchors on the *Titanic*, the two on the side were smaller and used for general anchorage. The center anchor, weighing fifty and a half tons, was mounted on the deck and would have been used as a drag anchor in an emergency.

The once-gleaming white anchor hoist, rising about ten feet above the deck, is mounted directly behind the anchor. With the aid of the boom mounted on the forward mast, it would have been used to help swing the anchor over the side of the ship when it might have been necessary to have a third anchor in the water. Originally facing the stern, the hoist now faced forward, its paint long disappeared and replaced with rusticles.

Anatoly had been diving on this wreck dozens of times, yet with all his experience the submersible ran directly into the hoist. The *Mir* tipped slightly and glanced off with no damage done to either the *Mir* or the hoist. Ralph later told me he doesn't know of a pilot who hasn't hit it. Fortunately, we didn't knock it over. None of the pilots wants that added to his resumé.

I barely noticed the jolt, but it made clear why Anatoly didn't like diving on the *Titanic*. We hadn't been here

more than a few minutes when something less than desirable had occurred. To me it was all exciting. By not knowing and understanding the full extent of the hazards, I didn't feel threatened. Nothing was said of the encounter inside the sub, and we continued on.

The hoist directly behind the center anchor becomes a hazard to anyone floating over the bow. Our submersible ran into it, fortunately without damage.

The anchor chains became the focus of my attention. Located directly behind the central anchor, these two sets of chains were attached to the main anchors on the sides of the ship. There are 1,050 feet of chain, each link weighing 175 pounds.

The hoist that we ran into was now between us and the bow. The base of it was welded to the deck and rusticles dripped from its arms. In some ways it looked as though it had been in a fire where bits and pieces had melted and warped and been made generally useless. The wooden deck has disappeared, eaten away by hungry wood-boring mollusk worms. Only the brass bolts that once held down the teak planking remain. They protrude in long, unsightly rows partially filled in with silt and other debris. Nothing was left of the previous splendor of this deck with every detail polished and clean. Yet it had an indescribable beauty and ghostly magic about it as we moved slowly overhead. The caulking between the planks remains, leaving a sort of map of the departed deck. At first glance, the caulking gives the impression the planking is still there. Some wood remains on the deck, but it isn't very distinguishable because of the sediment covering it. The little wood that remains is due to the metallic leaching still going on with nearby brass—a combination wood-boring worms don't find very tasteful.

Our lights cast long shadows and gave me a better perspective of what I was seeing. I wondered if these long shadows we were creating might be similar to those cast by the sun setting on the deck the last night the ship was at sea.

As we moved toward the bridge, I thought it would be the last I would see of the bow, but further down the deck Anatoly turned the sub around to give me a view of the bow from behind the anchor. Here we paused. I had my eyes glued to the viewport, again not believing what I was actually seeing.

The *Mir* hung there for a minute or two and then pivoted to the right and faced the bridge. Below me was a small winlass used to take up slack on *Titanic*'s mooring ropes and also to handle cargo. Ralph, who was looking at his monitors, fired off a few photographs. A white crab moved nearby. Another one sat perched on the anchor chain. Other small creatures swam by my view. It some-how seemed to me they were wandering around trying to find some purpose.

After cruising over as much of the bow as Anatoly and Ralph thought time permitted, the *Mir* slowly moved on toward the bridge. It all continued like a dream, with the *Mir* moving in slow motion; but like most good dreams it was over too soon. I was feeling strangely at home and strangely out of place as I looked out my tiny window at this seldom-visited surreal landscape.

Turning from my viewport, I glanced at Anatoly and Ralph operating the sub. My emotions jumped from a dreamy reverence to feeling like I was part of a sci-fi movie as we were enclosed in this small metallic sphere full of switches and gadgets.

Passing over the low, metal, V-shaped barrier called the wave guard and used to keep large waves from washing down the deck, we continued to enter an area where the remaining rivets once holding the deck planks were especially pronounced. At this point the width of the ship was sixty feet and fanned out to ninety-five feet at the bridge.

My attention focused on one of the capstans. With its top made of solid brass, it looked like new, since rusticles only attack iron. It stood out more than any other feature on the deck.

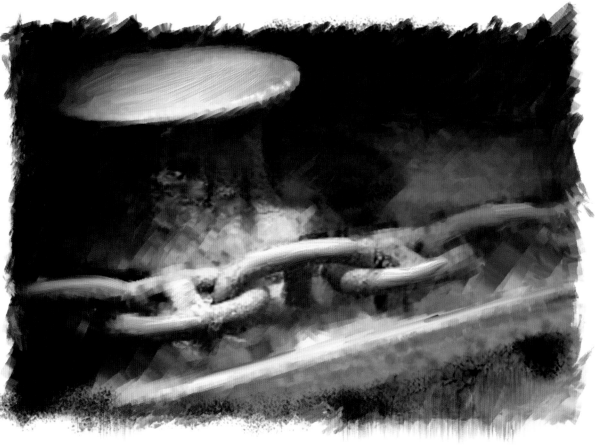

Moving slowly down the center of Titanic's bow, we could see the capstan, once used to tighten the mooring lines.

A pure white abyssal crab stood out in contrast and moved slowly across the top railing above a pair of bollards.

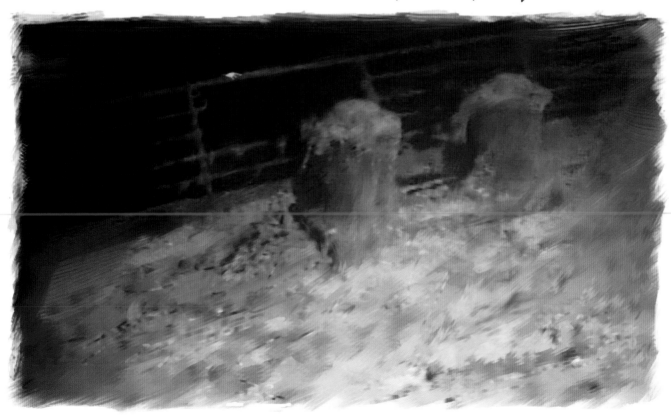

We swung around more to the right as we moved on between two large winches. The forward mast, which once held the crow's nest, came into view. I was amazed at its size. To reach the crow's nest, the lookouts ascended a ladder inside the mast. Of course, everything about *Titanic* was large, especially for its day. The ship itself was 882 feet long and 175 feet tall from its keel to the top of its funnels.

Upon sinking, the *Titanic* sped to the bottom at an estimated thirty to forty miles an hour. The forward mast gave way at this time and fell back onto the bridge. The wires that were once holding the mast in place were still attached but in disarray everywhere around the deck.

As we headed up the mast, I could see the hatch where the lookouts would have entered the cold night air forty feet above the deck. I can only imagine how cold it must have been for the lookouts in the middle of the night. I was staring down at the very spot where twenty-five-year-old lookout Fredrick Fleet first spotted the iceberg at 11:40 P.M. on April 14, 1912, and sounded the alarm by ringing the bell three times and phoning the bridge to say, "Iceberg dead ahead."

The crow's-nest has disappeared. It probably fell into the number-two hatch when a submersible bumped it back in the 1980s. Nobody is really saying. The bell was never observed even on earlier dives, and it most likely disappeared down the same hatch when the ship hit bottom. A bell was retrieved on a prior expedition, but it wasn't the bell from the crow's nest.

Along with Frederick Fleet, Reginald Robinson Lee was on lookout that night, and for thirty-seven seconds both men stood right in front of this hatch, Fleet with the phone in his hand waiting what must have seemed like an eternity while the ship slowly turned to port and then hit the iceberg.

Calm seas had made seeing the iceberg difficult. Had they been rougher, waves lapping against the iceberg might have made it visible. As it was, everything appeared black. A simple pair of binoculars may have also saved the *Titanic,* but the ones in the crow's nest had gone missing after the *Titanic* stopped in Queenstown, Ireland.

Both Fleet and Lee survived the sinking. Lee left *Titanic* in lifeboat number thirteen, and Fleet was placed in lifeboat number six, one of the first boats off the port side. Fleet and Quartermaster Hitchens were the only two crew members in the boat. The now-famous Molly Brown was also in the lifeboat and tried to get Hitchens to return and rescue more people, but Hitchens refused. Fleet, being junior to the quartermaster, had no say in the matter, but I'm sure the decision must have haunted him for the rest of his life.

Amazingly, Fleet worked on board ships for the next twenty-five years, but as time went on he ended up selling newspapers on a street corner in Southhampton. Shortly after his wife passed away, he committed suicide in 1965 at the age of seventy-five.

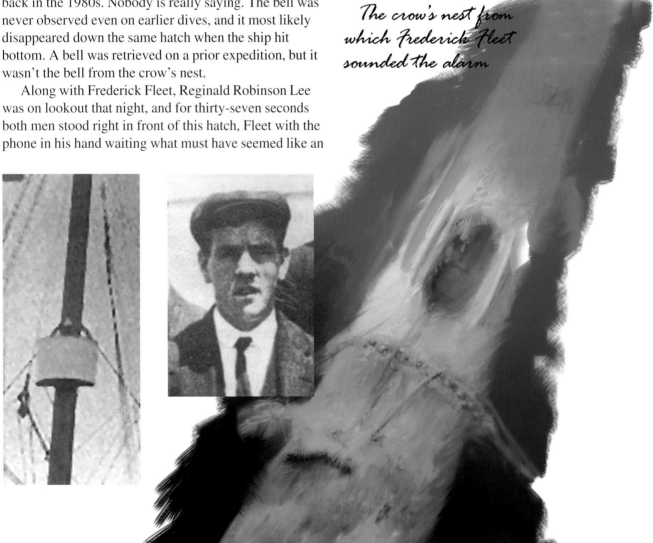

The crow's nest from which Frederick Fleet sounded the alarm

The mast, like the rest of the bow, is covered with rusticles. Still over the mast with the number-two hatch below us, I looked down into this, the largest of the cargo holds, where luggage and the now-famous Renault automobile were loaded onto the *Titanic*. The hatch covers were made of wood and covered with canvas, and as the ship sank air pressure would have built up and may have blown the covers away. I carefully stared down into the hold, but it offered just blackness in return. All the treasures hidden there would remain so, at least on this expedition. Then hatch number three, used for coal and more luggage, came into view. The decks below once held many third-class passengers who were trapped and drowned even before *Titanic* broke apart.

On each side of the hatch, two giant cranes used to lift cargo from the docks into the holds remain in place, facing each other with their long arms locked down. Without a little help from Ralph, it would have been easy for me to miss even such large pieces of machinery because the rusticles have transformed them into almost unrecognizable, shapeless forms.

Following the mast, we reached where it had fallen onto what is left of the bridge, three flights above the cargo hatches on the forecastle deck. The bridge was constructed of a metal framework and covered with wood. Guy wires attached from the frame to the funnel probably pulled the bridge all to pieces when the ship broke apart and the funnel fell. The rest must have disintegrated on its way to the bottom. Wood worms have finished it off, and nothing whatsoever can be recognized of the bridge except the telemotor. Floating peacefully through the bridge area, I found it hard to imagine all the activity that must have taken place here as the *Titanic* hit the iceberg.

By some miracle, the telemotor remains pristine. Its being made of bronze helps. This device attached to the ship's wheel and was the first in the line of mechanical devices through which the rudder was turned. The ship's wheel was the centerpiece of the bridge, but the telemotor was its heart. The telemotor stands at its post like a loyal sentry that knows its own importance in having helped to direct the ship's movement to the very end. It remains alone and unscathed by the disaster as a reminder of human inability to override the power of nature.

Just to the side of the bridge was one of the davits that lowered the number-two lifeboat into the water. *Titanic* had enough lifeboats to carry 1,178 passengers and crew, yet only 705 people boarded them. Even had all the lifeboats been filled, 1,049 people would have been left behind with nothing to look forward to except the twenty-eight-degree waters of the Atlantic Ocean.

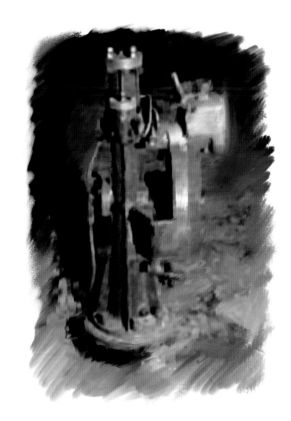

Nothing is left on the bridge of the Titanic except the telemotor, which once connected the ship's wheel to the rudder.

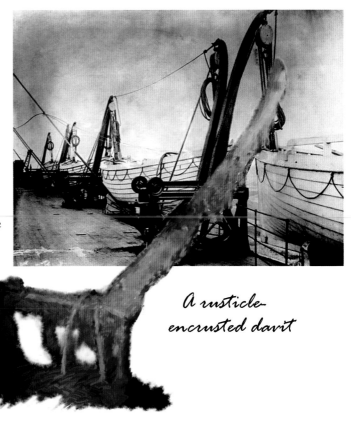

A rusticle-encrusted davit

Just below the bridge was Captain Smith's quarters. The deck has deteriorated and collapsed, exposing his stateroom and personal bathtub. It was partially filled with rusticles fallen into it from overhead. The bulkheads had collapsed since the last expedition, opening up the cabin even more, so most likely no more rusticles would be falling into the tub. The rusticles already inside the tub won't get any larger and fill it because they need iron to feed on, and the white porcelain won't supply it.

Rusticles are caused by bacteria that attack metal. As the bacteria consume the iron, the rusticles grow and elongate like stalactites in a cave. As a rusticle elongates, the outer portion no longer has direct contact with the metal to feed on and eventually dies and falls off. That's what has filled the bathtub. If, however, the rusticles, as they get longer, touch another piece of metal on the deck, they continue as an active colony and form what are called "rivers of rust," beginning to flow like lava with the aid of gravity. This deterioration continues throughout the

This was Captain Smith's bathtub and, can you believe it, it's still filled with water.

ship, and many of the decks are now so fragile they are the consistency of layers of wet paper towels.

Our small submersible moved toward the port side and the third officer's cabin. What is interesting is that on the very cold night that the *Titanic* went down, the two windows we were approaching were intentionally locked in the open position. It may have been that since the cabin door opens onto the passageway to the Marconi (wireless) room, the windows were opened so that officers could easily yell instructions and receive updates on rescue attempts from the radio room while launching the lifeboats directly outside on the boat deck.

Here is where people once crowded in desperation trying to get aboard the number-two and-four lifeboats on the port side.

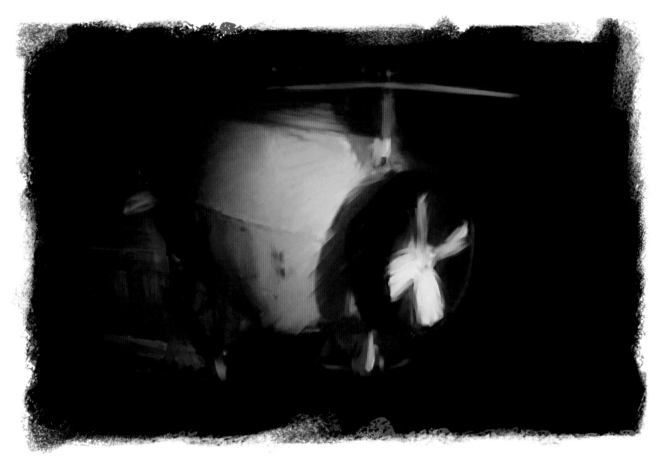

Moving over the bridge on our way to the Marconi room.

After leaving the bridge we passed over a gaping hole in the deck where the number-one funnel collapsed, and just behind it, saw the ship's expansion joint. Later on in the dive I spotted a very long piece of metal that looked much like the threshold of a door. After I pointed it out, Anatoly tried to pick it up. It snapped, but he caught about a two-foot section of it and we brought it back to the surface.

12:44 P.M.

We had been on the bow of *Titanic* for almost three-quarters of an hour and the Marconi room would be the next stop on our tour of the ship. The other submersible had already arrived there and was trying to deploy a remote operated vehicle called an ROV to go into the Marconi room for a look around. It had no ability to pick anything up and was basically a flying eyeball. We sat across from the *Mir II* as they tried their best to get the thing to work. Although it had tested out all right in the pool on board *Keldysh*, this was the first time it had been used at depth. It refused to budge. One of its two thrusters locked up. The two submersibles sat across from each

other for almost twenty minutes as the ROV did nothing but bounce up and down a little in one of the baskets normally used to retrieve artifacts. As there was nothing we could do, we left them and moved on and passed over the grand staircase area. Nothing at all is left of the elaborate wooden staircase, although several chandeliers remain hanging from their fixtures.

The ROV built by the Mir's crew on board the Keldysh.

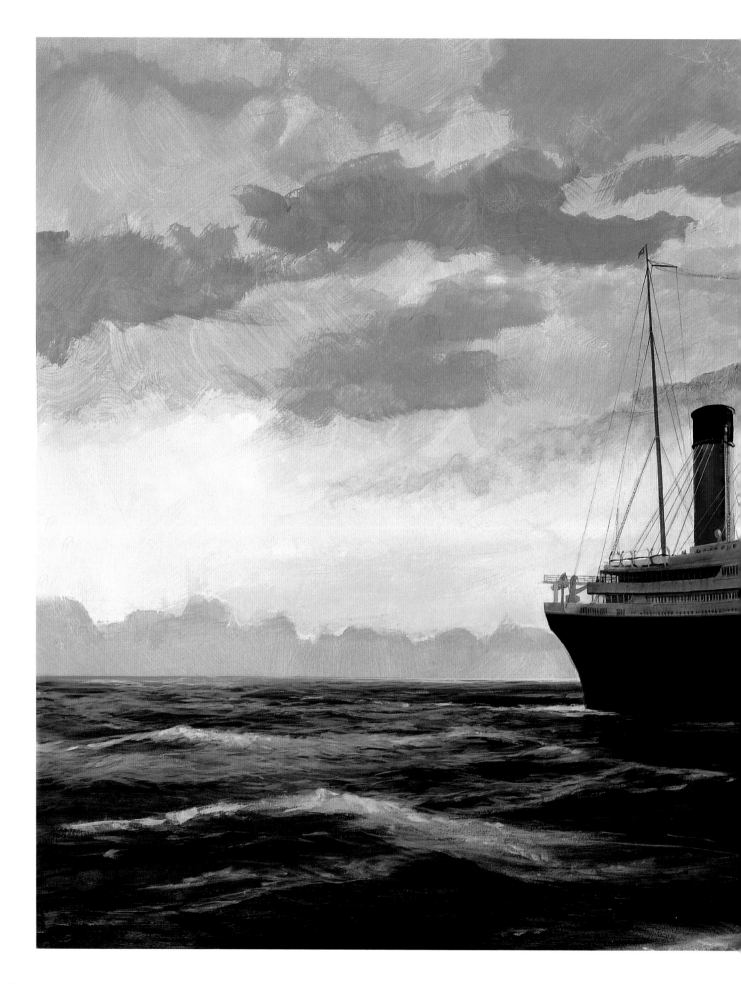

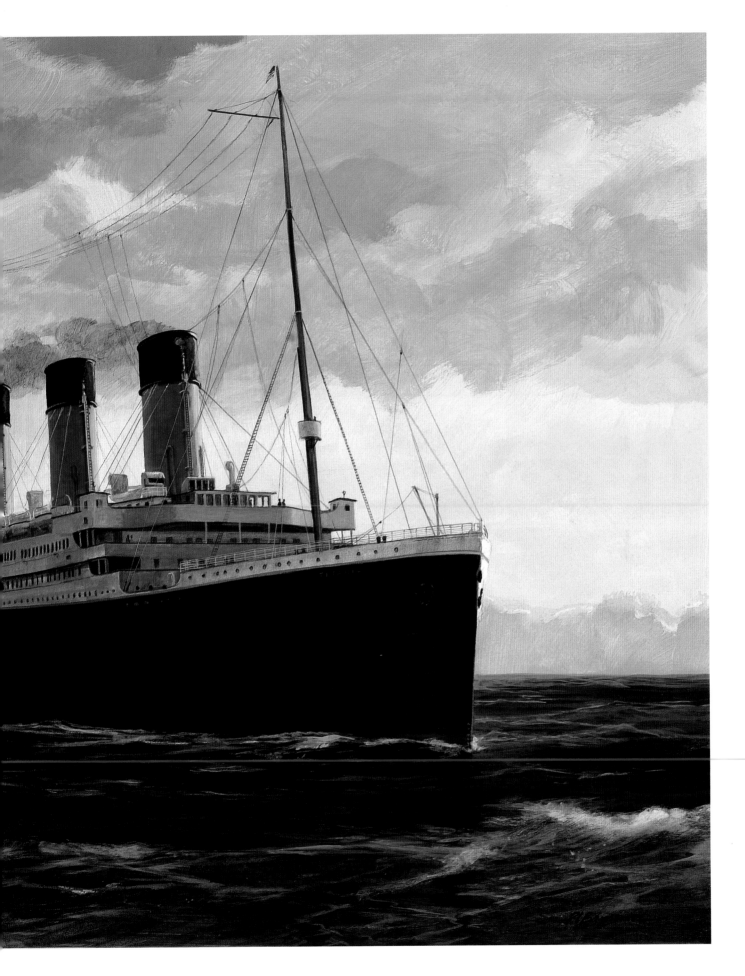

Oh, the pressure!

My job was basically keeping an eye out for interesting artifacts that might come into view in the debris field on the starboard side of the sub—not what anyone would consider a high-pressure job or overwhelming task. I was more than eager to do my job. Looking at it another way, there was tremendous pressure on me, but fortunately the *Mir* was absorbing it all at these depths.

The submersible in which I was a passenger is one tough little vessel. While we buzzed around the *Titanic*, 29,024,730 million gallons of sea water were directly over us, pressing down on us. At a depth of 12,500 feet, the pressure on the hull is 5,426 pounds per square inch. That is like stacking the weight of two moderately-sized cars on a space the size of a thumbnail. Ouch!

That's the pressure for only one square inch, but of course there's a lot more surface area to the submersible than that. The top of the *Mir* takes up a little more than 302 square feet. That comes to 43,488 square inches. One cubic foot of sea water weighs 64 pounds, so when the multiplication is done it means there is a total of 241,776,000 pounds of pressure trying its best to collapse the hull.

Fortunately, the crew's sphere in which we were enclosed was made of flawless solid nickel steel two and a third inches thick. At least I hoped it was flawless. In some places the walls of the sub were beefed up to a foot thick, for example, where the viewports were. As the submersible descends deeper and deeper, the seven-foot-diameter compartment actually changes shape, warps, and compresses. On some dives, Ralph would tightly attach a string to opposite sides of the sub. By the time the *Mir* reached the bottom the string would sag by an inch. With all this transformation going on, the greatest danger, I was told, was implosion.

The sphere is strong to a point, but when breaking occurs it isn't a gradual cracking that might give some warning of what is about to happen. Instead it would be a sudden event—bam! We're history.

Anything outside the sphere, such as camera housings or lights, are subject to the same conditions, and some of these have imploded in the past. I was told it was like a stick of dynamite going off, but in reverse. A huge bang is accompanied by an instantaneous movement of water filling whatever imploded.

Secondary effects caused by a smaller implosion can cause unappealing results to the sphere itself in one huge implosion. Here lies the danger. The acrylic viewport I was looking through was cone-shaped, four inches on my side and more than a foot across on the outside and basically sealed in place by the water pressure on the outside. The deeper we went, the tighter the seal. These windows were designed to actually change shape in their sockets slightly to keep from breaking as the hull contracted. Any implosion of a light or camera housing outside can create such a violent vacuum that it is possible the water pressure would be reduced on the outside and suck the viewport slightly forward enough to break the seal. If that happened, the entire cabin would be filled with water in less than a millisecond. The experience would happen across the sphere at about the speed of sound. We wouldn't know what hit us.

The incredible shrinking cup

For a rembrance of the expedition, during each dive we were all free to take as many eight-ounce Styrofoam cups from the dining area of the ship as we liked and write whatever we chose on the them with felt pens. They would then be picked up, placed inside a yellow mesh bag, and put in an unpressurized area of the submersible and taken to the bottom on the next dive.

When returned to the surface, they were about the size of a thimble and very hard. The 5,426 pounds of pressure per square inch created these unusual souvenirs. Most retained their shape, but occasionally one would distort. We were told to stuff tissue inside the cup to help it retain its shape, but I can't believe it would have had much of an effect. I think pressure being equal all the way around just crushed the cups slowly and evenly enough as they descended. The writing on the cups miniaturized as well, becoming denser and darker in color as the cups compressed.

I only made about a dozen of these cups. For some reason I didn't realize how fascinated people would be with them. Now I wished I'd made more to give to friends when I returned home.

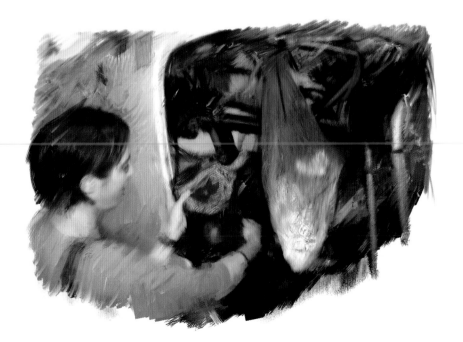

Stephanie, one of the American medical students on board, had a large Styrofoam cooler on which she had drawn Titanic's White Star logo across the top. She sent it with us to the bottom. When it came back up, the cooler was about the size of a small shoebox.

By what name?

As an artist, I have always thought it strange that someone would buy a painting of something old and broken down—for instance an old tractor sitting in a field beside a rundown barn—and hang it prominently in the living room as a thing of beauty. They would never want that rusted piece of equipment in their yard. Things take on different perceptions depending where they are placed and how they are presented. I couldn't help but make the comparison to the *Titanic*. Here we were looking for interesting pieces in what is called the "debris field." It's where the ship split in two. Stuff had spilled everywhere and spread out over an area of about three-quarters of a mile in the shape of a teardrop. When this "debris" is brought to the surface it becomes treasure. Put it in a museum behind glass and it becomes even more important and sometimes priceless. It's sad, but art is ultimately defined by what museums keep. One thing is for certain, it will all be returned to dust sooner or later in the larger scheme of things.

I can't begin to describe how many things are lying in the debris field. Almost as soon as we passed one item other bits and pieces came into view. The only place I

Many shoes are scattered near the Titanic. If they are lying side by side, it means they had been on what was once one of the nearly fifteen hundred bodies of people who lost their lives that night. The tannin content of the leather preserved the shoes, but all other traces of the person have long since vanished.

didn't see debris was right in front of the bow. Everywhere else I saw items large and small. Dishes, bottles, blankets, and especially shoes gave my heart a jolt. My eyes were fixed on many shoes as I looked down from my small viewport. We passed over them in what seemed like slow motion, and then they were gone from sight. It was like being a ghost floating silently over a transparent graveyard. Shoes were never disturbed by any of the submersibles.

Out of the darkness appeared impersonal items such as huge pieces of machinery parts with pipes, gears, and unidentified riveted sections simply torn apart like fragile toys in a tornado.

Checkerboard linoleum tiles that had covered the floors around the areas of the grand staircase were scattered here and there. Linoleum was new at the time, and I can attest to the fact it is one tough product that holds up well, even under water. Other items didn't fare as well. Some silver plates turned to absolute dust upon the first touch of our mechanical arm. Yet I saw a similar set of plates picked up and retrieved. It's hard to know why some items survive while other similar ones don't.

I knew that soon much of what I was seeing would revert to dust, just as much of *Titanic*'s treasure has already. By retrieving articles, we would allow future generations to see them and help keep the memory of the *Titanic* alive. I think that's a good thing.

Although the excitement was overwhelming, it was in no way a festive atmosphere for me or anyone else I know of who has been to the site. It is all carried out with dignity. No one knows just how they will react when they see the remains of the *Titanic* for the first time, but the need to be solemn was a natural response for me and others I knew who had gone down.

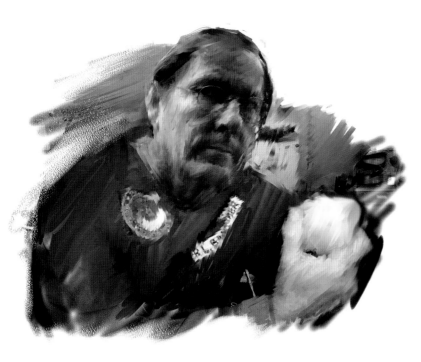

Ralph operating the cameras. Now here I was eating a candy bar looking out at *Titanic* and beside me sat the same people that were here during the filming. The only difference was that instead of James Cameron lying on the bench it was me eating a candy bar as if in the theater. How strange is that?

Lunch on the *Titanic*. It was very odd, and I don't think I will ever get over the feeling of being very misplaced at the moment—as if in a fantasy that only the sleeping mind could conjure up in a dream.

Some people believe that recovering artifacts desecrates this special spot, but the expedition was an attempt to save, not destroy. The most inappropriate thing I experienced while diving to *Titanic* was eating the cheese sandwich, not retrieving artifacts.

Our exploration of the debris field continued.

3:50 P.M.

Lunch on the *Titanic*

While over the debris field, we took a few minutes for lunch. Eating was not high on my priority list. I had not even thought about it, nor had I expected there to be any food on board until Ralph asked me to lift up the front part of the narrow bench on which I was lying. Underneath was a small compartment packed earlier by the friendly Russian chefs two and a half miles above us. Inside were small bags of cheese sandwiches, a few bars of German chocolate, and some pears. It was the sort of meal your mom would have given you as you went off to elementary school. The only thing lacking was the pickle.

If there was any one time while down on the *Titanic* I was aware of being uncomfortable, it was while eating. It just felt wrong to be having a cheese sandwich at such a place. There was something irreverent about it. That said, I ate the sandwich and pear and then munched on several of the chocolates while lying back down on my stomach to look out the viewport.

Millions have sat in dark movie theaters, many probably eating candy bars, watching the last moments of *Titanic* sinking on the big screen. The comparison was haunting me. Here I was with my chocolate in a capsule called *Mir I*, the very underwater vehicle featured in the movie *Titanic*. In fact, I was lying on the same bench James Cameron used while the bow scenes were filmed. Anatoly Sagalevitch and Ralph White were in this same submersible during that filming, with

The scrolled metal ends from a few of Titanic's benches came into view. How beautiful they were. I could only imagine the people sitting there with the cool sea breeze blowing by during the first few days of the voyage and then these same benches sliding down Titanic's decks and into the freezing waters as the ship broke apart.

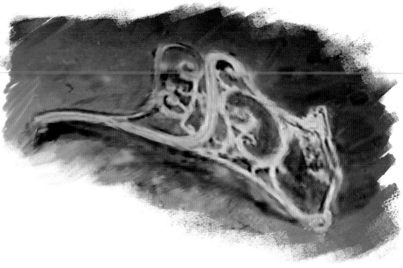

Before we had time to digest our sandwiches, we moved into an area filled with plates and bottles. In the distance I could see bottles of wine stacked one on top of the other. There were dozens of them woven top to bottom and probably two feet in height. At first I wondered how they could be stacked there so neatly but then realized the wooden crate had completely deteriorated, leaving the bottles still precariously balancing on top of each other. Any movement would surely topple them, but the still water leaves them to rest quietly decade after decade. I was amazed to see so many huge chunks of iron plate and machinery torn and twisted as if it were tinfoil and other items like these bottles remaining intact without

My starboard side viewport faced forward but was positioned to allow me to see more toward the right side. Since our cabin was round, all three viewports had somewhat different views. We could each see some things the others could not. At one point I spotted a large porcelain bathtub to my right. The *Mir* was making a turn at the time, so it came into sight suddenly. With excitement I spoke up rather loudly as it had been the first one I had seen since Captain Smith's tub near the bridge. Just at that moment the *Mir*'s skid grazed the edge of the tub, and I saw it split in two, falling in slow motion as a sediment cloud erupted. It was then past my view and I never saw it again. Strangely, no one said a word or even acknowledged

I spotted these plates just as a large rattail swam by.

so much as a chip. Some strange physical forces were taking place as this ship broke apart and plunged to the bottom.

Titanic's voyage to America from its last port at Queenstown, Ireland, was supposed to take five and a half days, but since it sank on its fourth day out, there were plenty of stores left on board, and they're all scattered on the ocean floor, including what was left of the 20,000 bottles of beer and 1,500 bottles of wine. All these items are now forever packed in sand except for the few things that have been retrieved.

what I had seen, and after mentioning it again with no response I thought I'd better drop the subject. Anatoly wasn't much of a talker to begin with, and maybe Ralph was just busy with other things, but for me it was an odd moment.

When you've got to go . . .

Since there are no toilet facilities on the sub, you may wonder what happens on a thirteen-hour dive. Well, simply put, each person on board has his own bottle, and if you think it's easy using one of these things in a space hardly big enough to change your mind, you're wrong.

Both Ralph and Anatoly have an unspoken bet going on between them that they'll never have to resort to using one of these bottles. As a result, they sit there about to burst but have never once uncorked this small and useful apparatus. That's okay with me, but I didn't share the same macho syndrome that they found so important. Instead I wrestled with my jumpsuit on one occasion and awkwardly made use of the facilities and felt much better for it. As for the women who dove during the expedition—I don't know and didn't ask.

Pierre, the bird man, was in charge of removing the bottles from the subs after they were back onboard the Keldysh.

Even today Titanic holds the record for having the largest steam engines ever built. There were two of these monstrous engines, standing thirty feet tall and weighing a thousand tons each. The piston had a diameter of more than eight feet across.
Notice the man standing at the bottom.

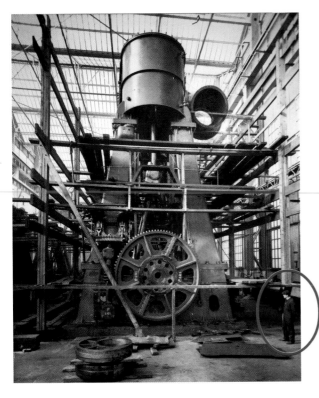

This is what that engine looks like now.

Close encounters

Toward the end of our dive, as we were looking around the debris field, Ralph sipped on a cup of hot Russian tea from his thermos. He nonchalantly looked at Anatoly and said, "Tolya, do you know where we are?"

Ralph, knowing exactly our position from the sonar equipment he was monitoring and also having a wider view with his video cameras than we did from our viewports, remained quiet for a few moments. Anatoly said nothing as he looked out.

Ralph lowered his cup as if nothing at all were happening. As he continued to stare at the video monitor he calmly said, in a voice you would expect to come from someone who was merely commenting on the fine weather, "Tolya, we're about to hit the stern."

The viewports were directed downward to better see the bottom, making it impossible to see what was overhead. Since the stern of *Titanic* was over us, Anatoly didn't realize his position until *Titanic*'s huge starboard propeller suddenly came into view.

When I last heard about something hitting the *Titanic*, it was an iceberg. It came as a huge surprise when I heard the warning of another impending collision flow from Ralph's lips. I just hadn't envisioned *us* hitting the *Titanic* when I started this journey.

Just then the *Mir* stopped with a jolt, and rusted debris from the stern began to rain down on us. I could hear it hit the top of the sub and watched as it began to fall past the viewport. As the debris reached the bottom it stirred up a huge cloud of fine white sediment that quickly enveloped us. That was the last I ever saw of the propeller.

When my vision through the viewport became completely obliterated, I took my video camera, pointed it at Ralph, who apparently still had some vision with his video cameras, and asked him to describe what was happening.

Still totally composed and still quietly sipping his tea, he began to speak in a low voice as if giving a talk to a group of bored high school students.

Ralph: "It's a place very few people have ever gone. Basically you're under about forty-five feet of the *Titanic* hanging over the top of you. Nothing but rusticles underneath. Right now I'm looking at an overhang that we're about to crash into."

Roger: "We just hit something again."

Ralph: "Now we have more rust falling on us. Close encounters of the worst kind."

Roger: "So, we hit the top of the stern from underneath?"

Ralph: "Yup. It only counts if stuff falls on us and traps us." Takes another sip of tea.

We were in what is called a white-out situation, where we could see nothing outside the sub.

Roger: "This is very interesting."

It was a dumb comment, but I could think of nothing better to say, and indeed it was interesting. I took Ralph at his word and figured at that moment the stern of the *Titanic* could possibly collapse, trapping us as Ralph had so eloquently put it. We too would be added to the list of those lost on the *Titanic,* but for some reason I wasn't

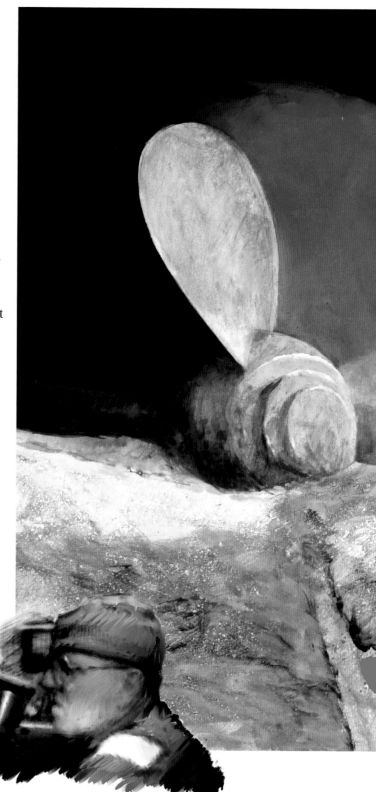

frightened. Had I fully realized the danger of the situation, I might have felt somewhat differently, but at the time it was more like a movie where you knew it was probably going to be just a close call like one of the tight spots Indiana Jones always manages to escape. It was better than considering the possibilities presented in other movies . . . like *Titanic*. None of this seemed real anyway, being down here on the ocean bottom, so I just enjoyed the moment as things unfolded.

This painting is a view of being under the stern. What happened to us was somewhat different as we hit the stern higher up with debris blocking out our vision.

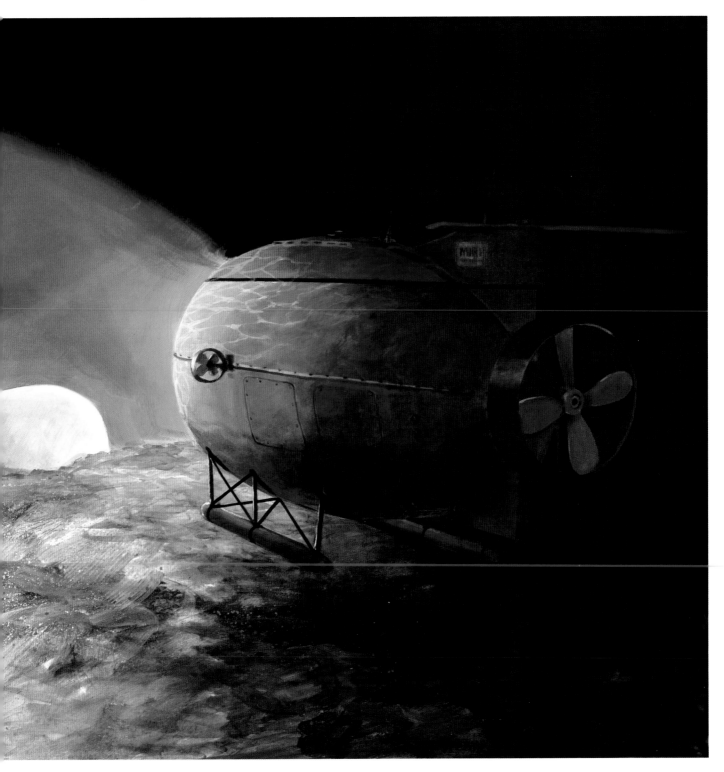

Being under the stern meant that all our communication with the surface was gone, and although from above our location was known, they had no idea of our situation. Anatoly wasn't in any hurry to get out from underneath this rusted and delicate overhang. Sitting there quietly until the dust settled was far safer than moving and possibly hitting the stern once again. With the fragile decks, there was a real possibility of the entire stern collapsing on top of us—though none of us let the emotions associated with that thought come to the surface either verbally or by eye contact. The stern was not the only hazard. When *Titanic* sank, the poop deck peeled back over the stern and has hung there precariously for decades, deteriorating away. It could collapse at any moment just on its own accord. A few taps from us could certainly set it off.

Neither Ralph or Anatoly showed any alarm or emotion whatsoever. Anatoly said practically nothing as he gently maneuvered the *Mir* according to Ralph's instrument readings. Ralph seemed to be enjoying his tea, probably thinking it could be his last. Unable to do anything, I continued to lie there calmly and watched as Anatoly and Ralph tried to figure out what to do. I'm sure had it fallen on us, attitudes would have changed dramatically.

Designed for luxury and not speed, *Titanic*'s top speed under its own power was about twenty-one knots, but when *Titanic* sank at a speed of twenty-five to thirty-five miles an hour, all this mass of huge iron sections twisted and tore apart either on the way down or upon impact.

When the *Titanic* finally hit the bottom, the poop deck peeled back over the stern, and the side-mounted wing propellers with their housings and shafts were literally bent upward forty feet to the height of the first portholes at F deck. The center propeller can't be seen and is forever buried forty feet in the sediment. Ralph's theory is that the back section of the ship hit the bottom with the stern pointing downward. It would certainly account for the force that bent the wing propellers upward and buried the rudder so deeply. The two electric cranes once mounted on the forward part of the poop deck also tore free when the ship hit the bottom and catapulted themselves directly behind and slightly to the starboard side of the main wreckage. It was likely they took part of the poop deck as it peeled over the stern where we were now unsafely tucked away in a cloud of sediment.

About ten minutes passed there under the stern until the dust finally cleared enough to let us gingerly move into a clear water column and free ourselves from the possibility of being permanent residents. After returning to the surface, Ralph looked up records and told me I was the sixth person to have ever been under the stern. Others have seen the propellers, but going underneath is simply too dangerous and just not done.

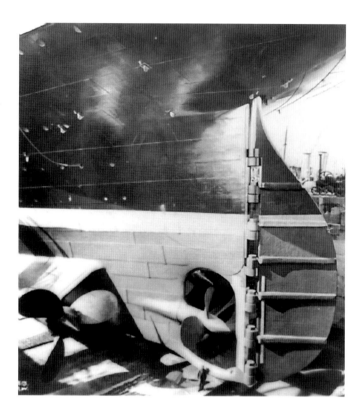

The center propeller, twenty-three and a half feet in diameter and weighing twenty tons, is now buried forty feet in the sediment. The wing propellers bent forty feet upward to the first portholes.

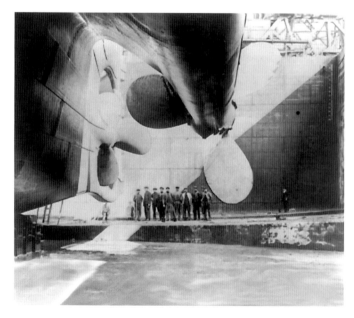

Light show from the deep

Time had slipped by so quickly, and I had seen more than I had ever hoped to, but the time came to head home after our grand finale under the stern. Anatoly began to pump out the water in our ballast tanks, and we prepared to make the two-hour journey to the surface.

All my senses had been subjected to intense overload from the past few hours of viewing the *Titanic*, but I had one more privilege in store for me. As I lay on the hard bench heading for the surface, thoughts of luminescent creatures from the deep came to mind. The creatures I had seen on the ocean floor were strange but weren't luminescent, and they were sparse, just appearing now and again, not in schools but like strays wandering in no particular pattern. I asked Ralph at what depth I might see creatures that glow in the dark. He replied, between fifteen hundred and two thousand feet. Anatoly had one of the small outside lights on since we were on our way to the surface. I asked him if he would mind turning it off for a time. He obliged, and I pressed my face once again to the thick acrylic pane. Dim lights were still on inside the cabin, so I took my jacket and wrapped it over the top of my head making a little fabric cavern to block out the remaining light. It also made me feel a little more one with the outside, isolating myself from the mechanical wonder in which I was a passenger. Tucking my portable CD player close to my chest, I attached the headphones, and inside my cocoon listened to more of the soundtrack from the movie *Titanic*. The powerful music made me once again aware that the *Titanic*, all 68,000 tons of it with many people, now perished, still inside, had furiously

ripped towards the bottom of the ocean in this very same column of water through which I was traveling.

For the next half hour or so I watched nature's light show of luminescent creatures pass my viewport. They replaced my thoughts of tragedy with their magnificent beads of light streaming by one after the other. Thousands of them. Some flashed brightly for an instant and then were dark. Some seemed to have a light that was constant and kept glowing. There were creatures whose lights were dim, while others burned brightly and ostentatiously. I couldn't see the creatures themselves, only their beacons flashing in the darkness. Some appeared like beads of sparkling pearls strung together in a chain as they flashed out what was perhaps a signal in nature's equivalent of our Morse code. It was a magnificent sight.

The sea was crowded to overflowing with these marvels that have never seen light except their own. The population of creatures right in front of my eyes was immense. It was a world very different from anything I could have ever imagined. Existing and functioning around the clock, it was an ethereal realm I had only heard of but, in fact, knew nothing about. Few people do. I was traveling up through their neighborhood, and the light show they were putting on was spectacular.

It was a wonderful way to end my journey to *Titanic*. It brought a peaceful sense of awe with it, finally one not associated with disaster and misfortune, and gave me reassurance that life exists everywhere, in this world and the next.

Retrieval

The retrieval process is similar to the launch but is often much more involved. If the seas are calm, things go quite smoothly. If the waves are kicking up, it can become difficult, time-consuming, and even hazardous.

The submersibles usually return late in the afternoon, or in the early evening as ours did, while there is still a bit of sunlight. Sometimes they stay down long after dark. When returning at night, the submersible turns on its lights several hundred feet under water. From the ship the submersible begins to appear as an eerie extraterrestrial glow in the distance usually off the side or stern of the ship.

We had been lying inside the *Mir* packed like frozen sardines for more than thirteen hours. The twilight from above began to filter into the viewports at a depth of a hundred feet or so, and the blackness began to lighten to a deep blue. As we continued upward, it changed to a lighter blue and then a green. I strained to look up towards the surface, and patterns of the waves began to dance from what little sunlight was still left in the sky.

The tow boat and the zodiac (rubber inflatable boat) had by that time positioned themselves above the light of the *Mir*, which shimmered from a hundred feet down. The light gradually got brighter and brighter until the sub broke the surface of the water, giving a science-fiction appearance to the end of the dive. As the sub started bobbing around in the swells of the Atlantic, the "cowboy" once again jumped on, connected a tow line to the *Mir*, and passed it off to the tow boat.

After an entire day at the *Titanic* we had finally returned back to the surface. From inside I watched as waves broke against the hull causing small bubbles to float past my viewport as if we'd come up in a glass of

While we were waiting inside the Mir, outside, the cowboy was hooking us up to be hoisted back on board the Keldysh.

The rounded submersible rolls easily from side to side even when the seas are fairly calm, making for a unpredictable ride inside the little cabin. Any large swell jarred us from our positions, and we had to brace ourselves to keep from falling into each other.

ginger ale. While waiting to be taken back aboard the *Keldysh,* I had a few more minutes to realize what I had done and where I had been. Returning to the surface was a bit of a letdown, like waking up from an incredible dream. I knew my journey was over and could never be duplicated and wished it could have gone on for days instead of hours, but I had no complaints. It was a feast for my eyes and senses I'll never forget. In addition, we brought back artifacts worth saving, and, best of all, we returned safely.

The dive left us all tired. The experience had totally drained me of energy. Many of my emotions were left behind to drift along *Titanic*'s wreckage, but enough remained for a lifetime of memories back here on the surface. I had returned from the most fascinating and moving thirteen and a half hours of my life.

The excitement wasn't quite at its end because the seas were rougher than when we had left in the morning. Waves tossed the *Mir* around as if it were a small fishing bobber in a big pond. A few large waves hit the sub, and because we couldn't see them coming and brace ourselves in preparation, it was all we could do to keep from slamming into something or someone when they hit. Being so cramped inside, we didn't have far to get thrown, but there was a potential for getting a little bruised. My biggest fear was accidentally hitting one of the many switches surrounding me. I almost fell off my small bench several times, but our retrieval turned out to be rather

tame compared to other dives when it had been much rougher. In most instances, the rougher the weather, the longer it takes to get back on board, and for those inside the *Mir* it can be very uncomfortable.

Inside the sub there was nothing to do but wait. It took about twenty minutes for us to be brought back on board, and fortunately any idea of getting seasick didn't occur to my subconscious. The mood during this time seemed a little strange. No one was talking or looking at each other. There were no congratulations about the dive nor talk about the artifacts we had just picked up. No excitement showed on anyone's face, just fatigue and reflection. Ralph and Anatoly stared blankly through instruments, almost like people watching the buttons in an elevator waiting for their floor to arrive. They were alert to what needed to be done inside the *Mir* but seemed to be running on automatic.

I lay with my face close to the viewport, staring at the bubbles from the waves overhead and participating in the silence during this unusual waiting period. It would have been eerier had it not been for the small wall-mounted speaker with its static-laden conversation in Russian going on between the tow boat and the *Keldysh* as they tried to bring us safely back on board.

The viewport that had been my eye to the special world of the *Titanic* was once again growing dim. This time it was not from the depths of the ocean but from the quickly fading last light of the day. It was as if the movie were coming to an end and fading to black.

By the time we were ready to be hoisted back on board, daylight finally succumbed to darkness and the lights from the deck of the *Keldysh* lit our little cabin. From inside I could feel the cable as it became taut and kept us from the side-to-side movements we had been experiencing since we hit the surface. As it stretched tight and began to pull us up, the water dripped down my viewport, sparkling from the floodlights like rain on the windshield in the headlights of an oncoming car. After an incredible journey the *Mir* was finally being swung back into its protective parking bay once again. So much had changed in those few hours. I had left with naive excitement and anticipation and returned with as much or more, but of a very different sort. Part of me had been left behind on the *Titanic,* and even though it was all still very fresh in my mind, I was sure that that part of me would always remain there. I would never be quite the same after silently flying over the *Titanic*'s bow, up the mast past where the crow's nest once was, floating past the bridge where the final orders were given, looking down

Coming back to the surface was like returning home after being in an extraordinary real-life time machine.

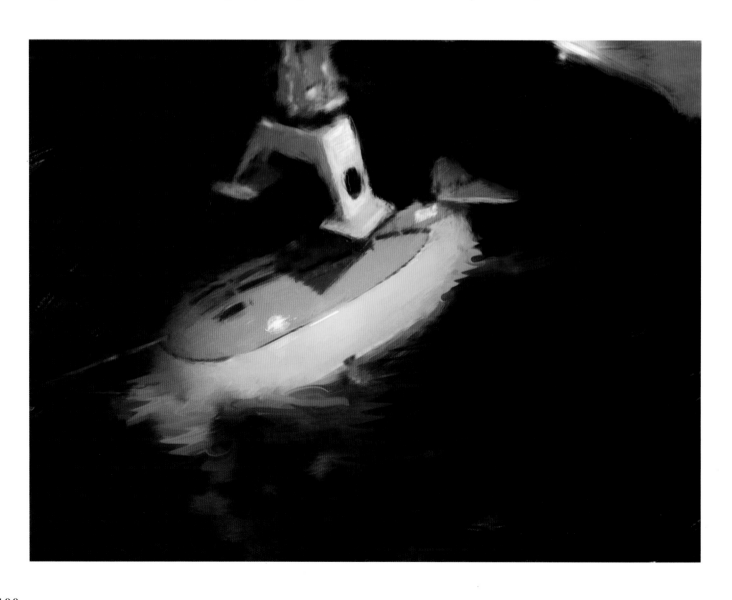

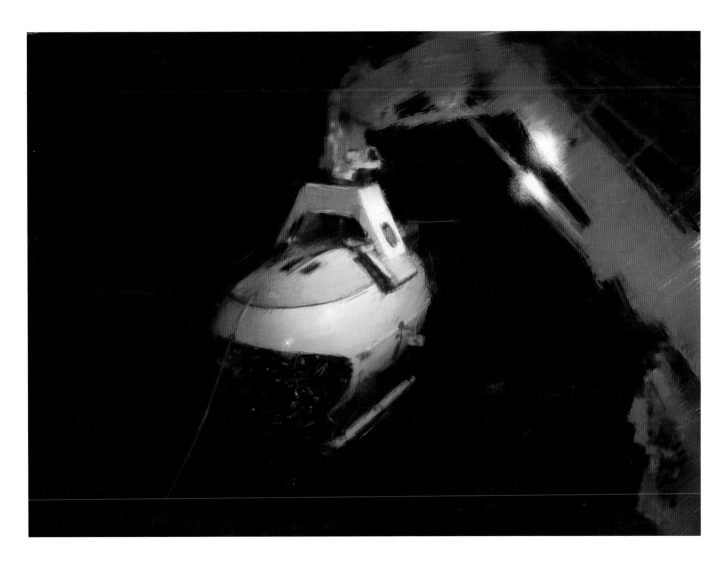

into the Marconi room where the SOS was tapped out, seeing the void that was once the grand staircase, exploring the debris field that seemed like some long-forgotten private estate where personal belongings lay silently for so many years, and ending the journey by being under the stern of the great ship as few people ever have.

We were back from a watery world to the planet of fresh air and human activity I knew.

Interviewed again

When I was interviewed before the dive, I talked with the reporter about my expectations. I really didn't know what to expect on the dive I was about to take. At that time I was just looking into the camera and saying what amounted to a lot of nothing. I've learned when a reporter is burning film and points his microphone in your direction, they really appreciate something being said even if it makes no sense. I know this from watching politicians being interviewed on television.

Having just returned from the *Titanic*, I could now express myself with something to say other than speculation. Although I was the observer on the sub, I was definitely a part of the crew.

My demeanor before going down was one of excitement and some nervousness, but I was fresh and ready to go. After I returned from the dive, my hair was soaked with sweat and my eyes were tired from intense use. I was physically exhausted and emotionally drained almost to the point of collapse, and I'm sure it all showed on my face.

As I talked to reporter Lloyd Sowers, I told him what it was like getting my first sight of *Titanic*'s bow and then rising up to see the railings and anchor. I was barely able to hold back tears when telling him how I thought of my own family and children when I first saw shoes but no footprints on the ocean floor.

I spoke to him for quite a long time, never stopping to think about what I would say next. A flood of emotions poured out of me like a powerful river bursting through a dam. The only times I paused were to keep from tearing up. When I felt tears coming on, I changed the focus of my thoughts to something less emotional such as what it was like inside the *Mir*.

If Lloyd hadn't done the interview so soon after I had arrived back on board the ship, I may have never taken the opportunity to let my sentiments flow so freely. I'm sure I would have talked to my friend Lowell about my dive, but telling him of my trip would have been basically recounting what he'd already been through the day before on his dive.

Lloyd and his cameraman Jason were on the expedition to do a television special but were not invited to dive. Talking to him for those few minutes made me realize even more how lucky I was to have made the dive and returned safely. I wished everyone on board could have had my experience.

Being in front of the camera became a wonderful platform that gently forced me to express my feelings to someone who not only wanted to get it on tape but was not going to dive on the *Titanic* himself.

Lloyd may not have known it, but it was the most important thing anyone personally did for me on the trip. Until the time of the interview we were inside the sub, where it wasn't the time nor was it appropriate to get outwardly emotional. The interview provided the release of emotions that had been building up all day during the dive. In that way Lloyd was not only a reporter but a friend who made my experience more complete.

I was later given a copy of the interview, and it's one of the best remembrances of my journey, although I find it extremely difficult to watch even to this day.

From that moment on, I would not talk about my dive to the *Titanic* for several weeks. Even after returning home I shut myself off from friends and only talked to my family about the details. I'm not sure the reason. One would think I would have been excited to tell everyone I knew, but it was not the case. It took weeks before I was able to talk freely about the experience to friends. Even now I think no one can really understand what it was like to be there, and neither words nor pictures can ever express it.

After all the efforts

More than nine hundred artifacts have been retrieved from the twenty-six dives on this expedition. Here are just a few of them. It was amazing to be able to see them all on the *Keldysh* before restoration had begun.

This porthole from either a first-class cabin or the first-class dining area was brought up on my dive. The glass was missing but the rubber seals were still intact and felt soft to the touch. I was amazed at how heavy it was. It took two of us to lift it onto the table.

Here is another porthole, this one from the enclosed promenade deck.

My friend Howard Howell spotted this block and tackle from one of the lifeboat davits. When touched, it just disintegrated into dust, but the hook was brought back. Ralph White told me that during one of his dives in 1987 he saw and photographed a block and tackle still hanging on lifeboat number four, but a year later it had fallen off onto the ocean floor.

The block and tackle as it appeared on the ocean floor

These were silver plates I spotted on my dive and Anatoly retrieved using the mechanical arms. Sometimes items like these crumble when touched, but another similar item right next to it might remain in good condition.

The items just brought up were not left in the open air for long but were removed from the *Mir*'s holding bins and brought to the artifacts room, where they were placed in tubs of fresh water. Crew just up from the dive were allowed to hold some of the artifacts and spend time looking over the things they had found and picked up just hours earlier. During my dive I spotted these silver plates in the debris field. The first set of plates we tried to pick up crumbled to dust, but Anatoly retrieved these plates without a problem. Being the first person in the world to hold them after they had been on the ocean floor for so long was once again emotional, and I wondered who had seen or held them last.

No one really knows why some items from *Titanic* maintain their integrity while other similar ones don't. These silver plates survived quite well. Although they were stuck together and couldn't be separated at the time we brought them to the surface, the restoration process would cure that.

Most silver plates are made of copper and then plated with silver. Over time the copper can dissolve in the seawater, leaving only the thin silver plating measuring between a half and one millimeter thick, about the thickness of a couple sheets of paper. When viewed on the ocean floor, the plates look in perfect condition, but since only the plating remains they disintegrate into powder at the slightest touch.

Most of these plates were stuck together but will all separate during the restoration process. The bottom side of one silver dish still shined like new.

When all the metal artifacts arrive where they will be restored, they go through a lengthy process of being submerged in electrolysis tanks, where an electric current passes through the water. This procedure forces the salt to migrate out of the metal and reverses the corrosion process.

As soon as they arrive on the ship, the artifacts are submerged in fresh water. When brought out for us to see, they were constantly sprayed with water. If allowed to dry out, the salt in them would crystallize and expand causing the object to crack, break apart, or simply crumble.

Many of the larger objects are kept in the electrolysis baths for years before the salt has been completely removed. Museums showing artifacts from this expedition would be exhibiting them in tanks for some time to come.

One of the most important and prestigious places to be on the Titanic was the grand staircase on C Deck. As first-class passengers got to the bottom of the stairs, this was the identification sign they would have seen. The "K" is missing, but the rest of these brass letters were still attached to a small portion of the oak paneling.

The appropriately named grand staircase as it appeared when the Titanic sailed.

The most artful artifact found during our expedition was spotted by Howard during his dive. What was almost passed up as being just some twisted iron was investigated further upon Howard's insistence. As Anatoly moved closer, they noticed that it seemed to have sculptural decorations on it. When it was picked up by the mechanical arms, the sediment fell away exposing the base to the cherub once gracing the landing of the grand staircase.

The base for the cherub as it appeared in the debris field being picked up by the mechanical arm of the Mir.

Every conceivable sort of artifact, from the inspiring to the very functional, was recovered from the Titanic. This toilet made of porcelain was from second class. The ones in first class were made of solid marble, and the ones in third class were made of iron.

This gold-plated chandelier once hung in the grand salon. Although now twisted and broken, it remains bright and shiny.

Although the *Titanic* was considered a ship of luxury, by today's standards we would not be too impressed with some of its facilities. There were only nine private bathrooms on the ship. Only six of the first-class cabins had a private bath. Everyone else had to "go down the hall" to community bathrooms. The other three baths were in the captain's room, the chief engineer's cabin, and the first officer's cabin. Even elegant suites such as Molly Brown's didn't have a private bath.

There are many toilets throughout the debris field since most of the bathrooms were located in the area where the ship broke apart, and they were scattered as the ship sank.

An expedition member holds a lump of coal brought up from the debris field.

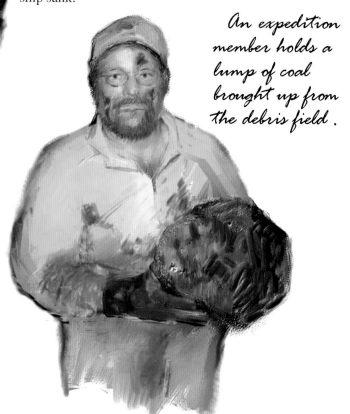

Titanic was carrying 6,000 tons of coal when it left England, and even though it burned huge amounts—its boilers using it up at a rate of 650 tons per day—since it was only at sea for three days, there was plenty of coal left in its hoppers. I observed large chunks of it scattered all over the debris field, not particularly concentrated in any one area.

There were two sizes of coal on board. The smaller pieces were used in the galley for cooking purposes. The larger chunks were from boiler room number one and spilled out at the surface as the *Titanic* broke apart.

Artifacts, both large and small, came back each day. Here is a wrench from the engine room once used to tighten the engine bearings.

This speaking tube was used to communicate from areas such as the bridge to the engine room. It would be interesting to know all that was said through this very tube at 11:40 P.M. when Titanic hit the iceberg.

Americans have a love affair with the romance and history of the *Titanic*. Combine this with the materialistic side of American culture and you have a powerful, motivating, and potentially explosive situation. The relics we brought up are part of history and worth many millions of dollars. Such things can bring out the best or the worst in human nature.

The tension is particularly poignant for those heavily invested in the retrieval of *Titanic* artifacts. I can understand it, as there is a lot at stake. Fortunately for me, I was just the artist and the nonpaying guest. I was responsible to no one, so my entire experience was exciting and carefree. I just hoped our expensive dive would pay off for all those involved in the investment.

The Russians have a different view of these expeditions. The *Keldysh* is a research vessel and has been on many scientific missions. Diving to the *Titanic* is pretty much a waste of time from the point of view of the Russian researchers. Salvaging pieces of the ship and its contents is of little importance to them. They participate in order to raise money to carry on more important scientific tasks and finance their research in other areas.

Chief archeologist Jim Sinclair, who specializes in historic shipwrecks, poses beside a brass hot water heater, of which there were many around Titanic dining rooms to keep the English constantly supplied with hot tea.

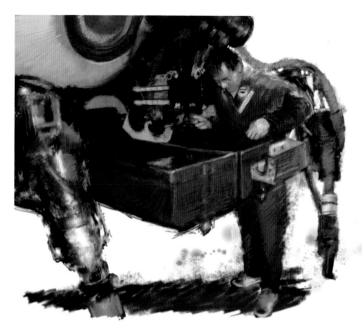

It's just rust.

Just under the viewports of the submersible are two metal baskets used for holding artifacts picked up with the mechanical arms. They are tucked under the belly of the *Mir* and slide out like a kitchen drawer when needed. The *Mir* can carry 550 pounds to the surface in the baskets, and they are usually overflowing with artifacts by the end of the dive.

No one is allowed to keep or own an artifact from the salvage mission, but after all the artifacts have been removed from the bins, little rusty chips of metal remain on the bottom of the basket. The Russian crew who clean the subs before the next dive spray the baskets clean with a hose and the chips wash overboard.

Sometimes we were able to rescue some of the fingernail-sized pieces before they were washed away. These little fragments can be souvenirs. It's like having a pebble from the moon.

Watertight doors

There were sixteen watertight compartments on the *Titanic* with heavy gears on each of the watertight doors. All the doors were closed by First Officer Murdoch as soon as the iceberg was sighted. But the compartments were really not watertight at all because they were like boxes with no lids. As soon as *Titanic*'s bow started to dip downward, the water became high enough to spill over into the first compartment. As one compartment overflowed into the next, *Titanic* eventually sank.

One evening Jim Sinclair and I were in the artifacts room looking at a gear from one of the watertight doors that had been retrieved. It seemed to have no distinguishing marks. I then rubbed some sediment off the face of the gear and found the number 401 stamped into it, the number used during construction to signify *Titanic*.

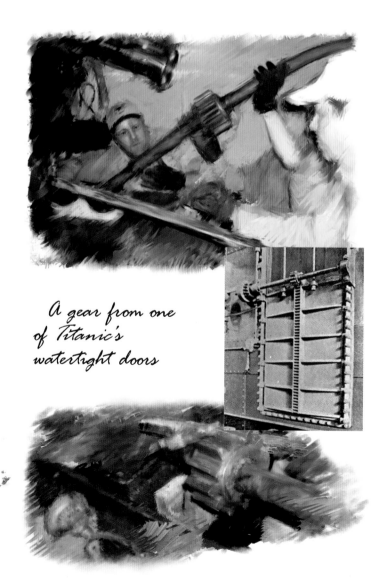

A gear from one of Titanic's watertight doors

A few rusted crumbs from a once majestic ship

Titanic's last instructions

What they called the "telegraph" on *Titanic* was not what we commonly think of as a telegraph, but it did relay commands from the bridge to the engine room such as "full ahead," "half speed," "stop," and so on. Orders were also given by way of a speaking tube, but in a noisy engine room the telegraph's dial made the order unmistakably clear so the engineers didn't have to rely on the verbal instructions.

It seems logical the telegraph would tell the position of the *Titanic* when it sank, but since it worked with gears similar to a bicycle with a chain and sprocket, the chain was pulled to its maximum extension and snapped when the ship broke apart, altering the position of the last instruction.

The wooden handles are still attached because the wood bore worms didn't like the flavor of the metal attached to the wood.

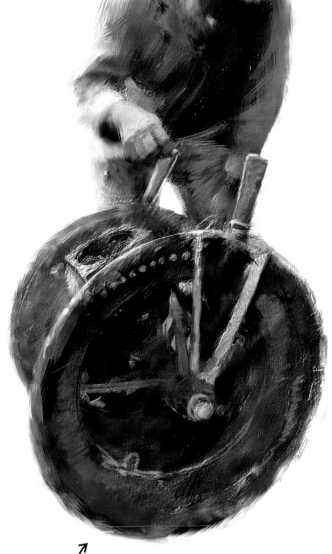

The "telegraph" probably used by First Officer Murdoch to tell the engine room "full astern" just before the Titanic hit the iceberg

Ralph and friends looking at artifacts brought up from the day's dive

109

The perfume in these vials still maintains its fragrance.

White Star Line brass buttons from an officer's jacket

A lady's mesh purse

Getting personal

A man named Adolphe Saalfeld from Manchester, England, was a first-class passenger of the *Titanic* on his way to America to further his profession as a maker of perfume. Although he survived, his perfume was lost until our expedition. Sixty-five small vials he most likely would have used in New York to convince department stores to order and sell his fragrances were all retrieved intact.

 Wrapped in a small leather case, the bottles were each a slightly different shape and color, and their scent filled the artifacts room after almost a century of lying on the ocean floor next to the *Titanic*.

Everything from pots and pans to luggage was laid out on a table for all of us to see.

What looks like a small light fixture is actually a soap and sponge holder still mounted on a piece of marble.

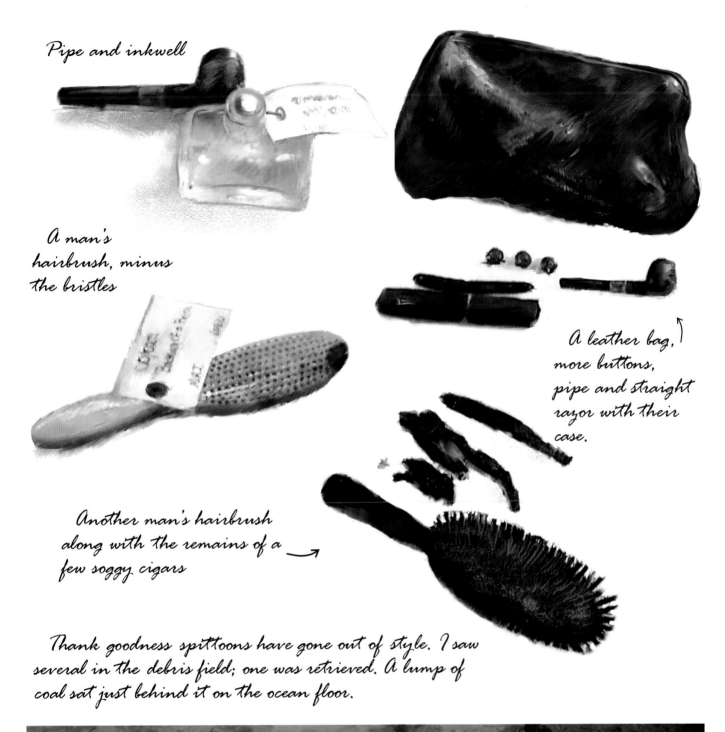

Pipe and inkwell

A man's hairbrush, minus the bristles

A leather bag, more buttons, pipe and straight razor with their case.

Another man's hairbrush along with the remains of a few soggy cigars →

Thank goodness spittoons have gone out of style. I saw several in the debris field; one was retrieved. A lump of coal sat just behind it on the ocean floor.

William Henry Allen

Leather bags are prized items to retrieve from the *Titanic*. Unlike machinery or even plates and dinnerware, a leather bag is filled with belongings and tells a very personal story. We saw several bags on my dive. We passed a few before the *Mir* could slow down enough to stop and try to retrieve them. It's almost impossible to back up or turn around because the sediment behind us gets stirred up too much and waiting for it to settle takes too long.

Leather bags hold up quite well because they have been treated with tannic acid, which the creatures and bacteria down there find unappealing. They leave not only the leather bags alone but also their contents.

Several times we tried picking up a leather bag that simply fell apart like wet paper towels. Seeing it happen was upsetting. I knew it contained someone's possessions that would be so much more appreciated in a museum than on the ocean floor. Leaving the bag and moving on most likely meant the items would never be seen again.

I know many believe that removing anything from *Titanic* is a bad idea, and when I tell stories about trying to retrieve things that are basically destroyed it makes them even more upset. My stance is that items brought up will be cherished and help to keep the memory alive for much longer than if they just dissolve on the sea bottom. Of course, eventually it will all be dust and rust wherever it is, so maybe it doesn't make much difference.

But sometime during the afternoon of my dive one William Allen went from being an almost anonymous third-class passenger to someone people will know a little more intimately for hundreds of years in the future. It began when Ralph spotted an object and Anatoly came to a stop directly in front of it. It was a leather bag, larger than any other leather bag that had ever been picked up at the site.

As I looked out the viewport, Anatoly gently moved the awkward mechanical steel arms and positioned them to where he thought he had the best chance at lifting the bag. I watched and grimaced as part of it tore, thinking this was another retrieval attempt that would end in failure.

It was a time-consuming process, and it didn't look hopeful since the bag was partially submerged in the sediment. It ripped a little more as the mechanical arms pushed at it, and Ralph said, "Anatoly, let's move on, there'll be others." Anatoly, short on words but long on patience, merely kept fighting with the bag, knowing it could turn to dust at any moment. Finally we watched as the bag was lifted up and dropped into the metal holding bin underneath the *Mir* with a crash and cloud of yellowish dust flying everywhere.

These items representing a life would now help preserve an important part of history. Gathering a few items like this made me feel like a true explorer bringing back to earth something until now unknown.

When we returned to the surface and the bag was opened, all the items were carefully taken out and placed on a table. Before us was all that remains from a third-class passenger by the name of William Henry Allen. He perished along with 1523 other passengers and crew when the *Titanic* went down. He might have been standing on deck with this very bag in his hand, watching as the bow of the ship lowered into the freezing Atlantic water. With all the lifeboats gone, he must have clutched this bag, his last connection to his personal belongings. He might have abandoned it before the ship actually went down in order to help others, or maybe it was it in his hands as he felt the water come up around his feet. Had he put on all the clothes it contained layer over layer, he might have kept warm enough to have survived long enough to be picked up by a lifeboat.

Bus tickets and a pencil from the bag of William Allen

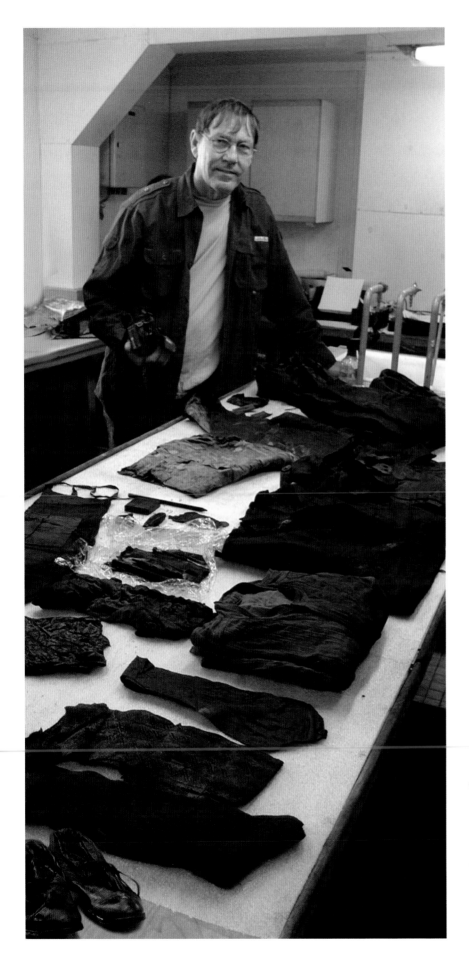

He was on his way to America like so many others to begin a new life, and since he was a third-class passenger all the items in this bag undoubtedly represented his entire material wealth. He would have taken everything here to his new start in life.

All we know about him besides what was in his bag is that he was a thirty-five-year-old toolmaker from Lower Clapton, Middlesex, England, who boarded the *Titanic* at Southampton with ticket number 373450 which had cost £8 1s (8 pounds, 1 shilling), about thirteen dollars.

His body was never recovered, or if it was it was never identified. What we know about his personal life came to the surface with this bag. Inside were some shirts and several pairs of shoes, pants, and socks. There was also a small sewing kit with thread wrapped around a flat paper spindle. He had one pencil and a pocket knife. There was also a cigarette lighter and a key chain fashioned like a miniature pistol. Everything was neatly packed.

There were also two bus tickets. Perhaps he kept them as a souvenir of his bus ride to the dock, a reminder of his homeland, which he would never see again. It was very sobering to be close to these belongings and to know I was involved in the final chapter of his life.

Taking a closer look at the belongings of William Allen

The ship's wheel

One of the most exciting finds during the expedition was
the ship's wheel. There were three wheels on *Titanic*. One
on the stern was to assist in docking, although normally
tug boats were used for that purpose. The two important
wheels were on the bridge.

The one in front was used in good weather and was
somewhat open to the elements. The other wheel on the
bridge was in a totally enclosed area and was the one in
use the night *Titanic* hit the iceberg.

Ralph found them on a dive a few days before mine.
The wheel used the night the ship sank was lying on the
starboard side of the ship partially hidden by a collapsed
bulkhead behind the officers' quarters about a hundred
feet back from the bridge.

*Only three mahogany spokes remain on Titanic's
main wheel, but what a story they have to tell. This
was the wheel being used when Titanic hit the iceberg.*

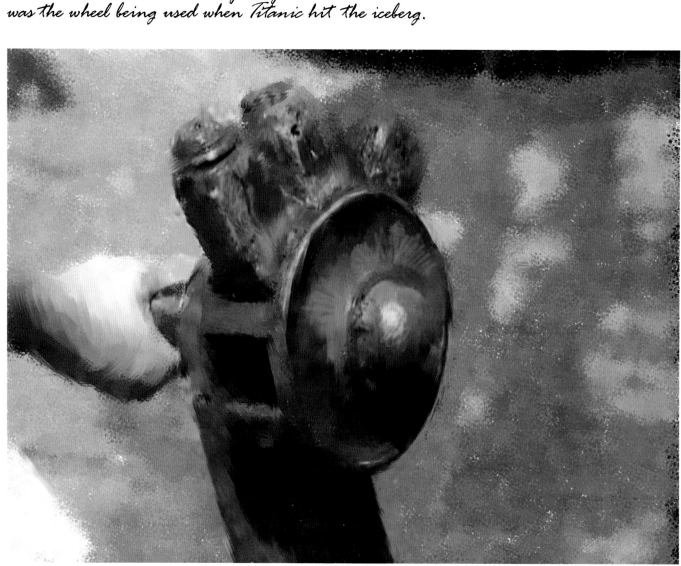

One sunny afternoon everyone on board had a chance to be beside the wheel for a few minutes to have a picture taken. The wheel was carefully brought out and each of us had a turn kneeling down beside the very wheel Quartermaster Hichens was holding at 11:40 P.M. on the night of April 14, 1912, when *Titanic* hit the iceberg and placed its mark on nautical history like no other ship in the world.

Just being close to this wheel was an emotional experience, and being right over the wreck site knowing *Titanic* was resting quietly on the ocean floor two and a half miles below made it even more meaningful. Had I been in a museum looking at this wheel I would have looked at it with wonderment, but actually holding the wheel at this location where the ship went down was a special privilege.

Alongside

All the artifacts brought up from the expedition were to be transferred from the *Keldysh* to the *Explorer*, the ship I had arrived on. The *Keldysh* was heading back to St. John's, Newfoundland, and the artifacts were going to Norfolk, Virginia, where conservation efforts would begin. From there some items would be sent to *Titanic* exhibitions for display and others would be put away until decisions could be made as to their best interest. The *Explorer* came alongside in calm conditions and tried to raft up to the *Keldysh*. Everyone was on deck for the event. At that time all the artifacts hadn't even been wrapped, so I'm not sure what the plan was. During my Navy days I had watched many ships come alongside in the open ocean so I knew this was not an impossibility, but for some reason the *Explorer* just couldn't make it happen. After an hour of maneuvering and two hard bumps to the *Keldysh,* the *Explorer* cast off and disappeared. No one in authority talked about it, although the rest of us thought it was just a matter of bad driving on the part of the *Explorer.* We assumed the transfer would have to take place another day.

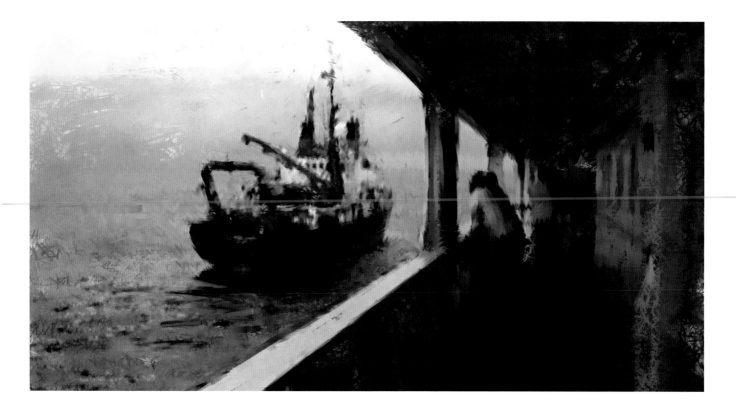

Moving day

The next day arrived, and it was nearing the end of the expedition. The artifacts would have to be moved over to the *Explorer* one way or another. Several people were in charge of artifacts and had carefully guarded, logged, and cared for each item. But now their job took on another phase—supervising their transfer between ships.

The nine hundred artifacts were piled around the deck in every sort of container. Each needed to be carefully packed and moved from one ship to the other, and the seas had kicked up slightly with large swells. I'd like to say that everyone involved had the utmost respect for the artifacts, their historical significance and condition of delicacy—not to mention the cost at which they were retrieved—but there were so many items, it was more work than just a few people could do. I think they made every possible effort to protect the artifacts with the materials at hand, but moving delicate objects from one ship to another in the middle of the Atlantic is no easy task even in the calmest of weather. All the objects had to be wrapped and then placed back in containers full of water to keep them from drying out. It was one huge job.

Artifacts on deck being readied for transfer

I felt a part of history as I packed the ship's wheel.

The final touch

Activity was at a fevered pitch with the transfer under way. Lowell and I tried to be good guests, making ourselves as unobtrusive as possible so as not to interfere with the activities of the transfer.

With that strategy in place, I was off to the side taking photographs when someone called out, "We need some packers here." My eyes shifted over to Lowell as his eyes met mine and widened. We were both thinking the same thing: a chance to touch some more history, handling artifacts that hadn't been seen by anyone but the few of us on the ship for generations but would be treasured for centuries to come. What an opportunity!

At about the same instant we both raised our hands and volunteered to do whatever needed to be done. Neither of us felt competent to pack priceless relics, but we quickly got the go-ahead.

Much to our amazement, sitting there on a table near us was the ship's wheel. Again Lowell and I looked at each other and said to ourselves, "Hmm . . . yes. The ship's wheel. We'll be happy to pack the ship's wheel."

Lowell and I knew as we packed the wheel it would never be back here at this location over the *Titanic* again but rather on exhibit in a museum somewhere in the world.

Being given the privilege of packing it gave us our own little private and personal spot in history. Although the officers of the *Titanic* were the last to handle the wheel just before it sank, Lowell and I ultimately became the last people to touch *Titanic*'s wheel at the very spot where it hit the iceberg and sank.

We now share in an experience with *Titanic*'s wheel vastly different than the officers on the bridge, but in some sense we gained a special kind of link with this part of history that will now always be a part of our lives.

We carried it into a small room away from the activity and began packing one of the most important artifacts ever to be recovered or that ever *will* be recovered from the *Titanic*, valued at millions of dollars. I doubt anyone in the future will ever touch *Titanic*'s wheel again for the amount of time Lowell and I did, especially without wearing white gloves, which were not available to us. The packing had become a frenzy with the other ship alongside and waiting. Why else would they have been asking for amateurs like Lowell and me to pitch in and pack such valued articles? I've crated many paintings and have always taken care in doing so but had never wrapped anything like this before.

Even though we didn't have any packing expertise, we were fully aware of the precious cargo. We took all the care we could so as not to harm any part of it, especially what was left of the fragile wooden spokes. We spent about an hour wrapping the wheel using foam rubber and lots of tape. It would have made a great commercial for the manufacturers of duct tape.

Of the many highlights on the trip, this ranked up there near the top. It would be hard to describe the emotions and thoughts we were experiencing during the time we spent on the wheel. We just kept looking at each other and saying in wonderment, "This is it! This is *Titanic*'s wheel." We talked about the officers on the bridge, including Officer Hichens who was at the helm, and wondered what thoughts were going through his mind the last time his hands were on it.

Lowell and I carry the ship's wheel wrapped in foam and duct tape before the transfer.

Parting ways

Transferring the artifacts took the best part of the day. Instead of trying to tie up to the *Keldysh* as it had done a few days ago, the *Explorer* stayed several hundred yards away. Since artifacts could not be handed from ship to ship, another approach was taken. All the wrapped and taped artifacts were secured into plastic containers and then placed in very large yellow metal cages. After being securely locked down they were connected to large floating rubber bumpers and then hoisted over the side into the water where cables had been attached between the two ships. With the artifacts bobbing in the water, the cable was slowly pulled towards the *Explorer* and the cages hoisted back onboard. The work continued until the end of the day as the sky turned shades of gray. It was a befitting end to the adventure.

I spent some time on the small *Koresh* as it was keeping an eye on things between the transfer points. When the ships' lights were turned on, it signalled—to me, at least—a sort of loneliness and parting. I felt like I would soon be leaving a friend's house, most likely never to return.

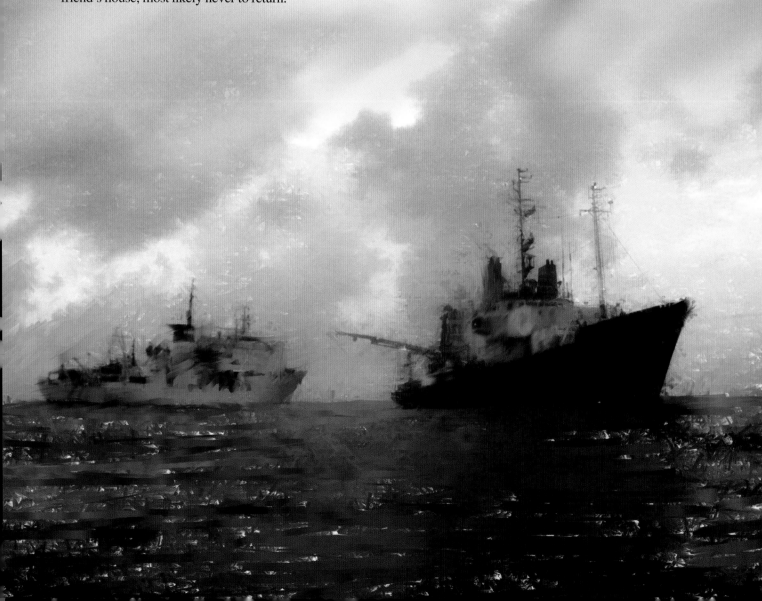

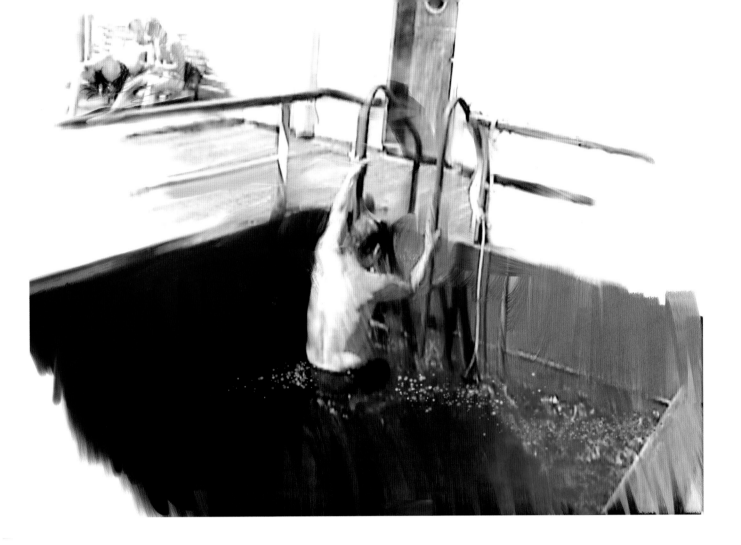

The awakening

I wondered what it was like for those fifteen hundred souls who lost their lives that night of April 14, 1912, in the cold Atlantic waters. Before we left, I wanted to get in the water for the experience. Just jumping overboard wasn't a very good option, and my request to do so was met with some rolling of the eyes from those in charge. My only alternative was to simply get in the small swimming pool located on deck. The water was pumped directly into the pool from the ocean and included an occasional small fish that happened to get sucked in. Being a Florida boy, I am not accustomed to cold water. When the Gulf of Mexico drops below eighty degrees, Floridians generally don't get more than a few toes wet and then retreat with some excuse about leaving enough room in the Gulf for the snowbirds.

But I was determined to feel a little of what those people who perished on the *Titanic* felt, so I donned my bathing suit and eased my way down the ladder into what I expected to be the thermal shock of my life. Instead it just took my breath away then made me just numb enough so I could swim for about fifteen minutes. I certainly wasn't anywhere close to dying of hypothermia.

I got in the pool on that August day thinking I might experience water as cold as the *Titanic* passengers had. But there were no icebergs in sight and I had a revelation about the *Titanic*, one of those revelations you are embarrassed to tell anyone at the time since surely it has always been obvious to them. If *Titanic* had sailed later in the year, say August instead of April, it would have been just one more large, new ship crossing the Atlantic on its maiden voyage. It would have arrived in New York with fanfare and then have been forgotten when a newer, larger ship did the same thing.

Very small things can make huge differences in peoples' lives. Had the telegraph messages about icebergs been delivered promptly and heeded, had the binoculars been in the crow's nest, had pride not been placed ahead of safety, the *Titanic* story would have been very different. Paying attention to those small differences may be the biggest lesson *Titanic* can offer us.

Heart of the ocean

When I was sitting in port at St. John's, Newfoundland, waiting for the weather to improve at the *Titanic* site, I picked a few of the wild roses growing just about everywhere. I had wanted to bring something with me from home to the *Titanic* as sort of a souvenir that I could bring back to my children and family, but I came here on such short notice I just wasn't able to think of anything for that purpose.

Then, at the Cape Spear lighthouse, I decided to pick lots of these roses and put them in my bag. Many of the petals fell off and I pressed them between the pages of my Bahá'i prayer book. These petals became my symbolic gift to the people I love.

All the petals went down with me on my dive, and not until after being at the surface again did I remember that Gloria Stewart, who played the older Rose in the movie *Titanic*, dropped the "heart of the ocean" overboard from the *Keldysh*, and here I was with all these special rose petals. When Gloria Stewart dropped the jewel in the water, the *Keldysh* was actually only five miles outside the harbor of Halifax, Nova Scotia. But I was right over the *Titanic*.

So just before I left this special place, while it was quiet and no one was on the fantail of the ship, I climbed up on the first rung of the very same railing where Gloria Stewart stood in the movie and, in memory of the fifteen hundred people who lost their lives when *Titanic* sank, I sprinkled a bouquet of these rose petals over the side.

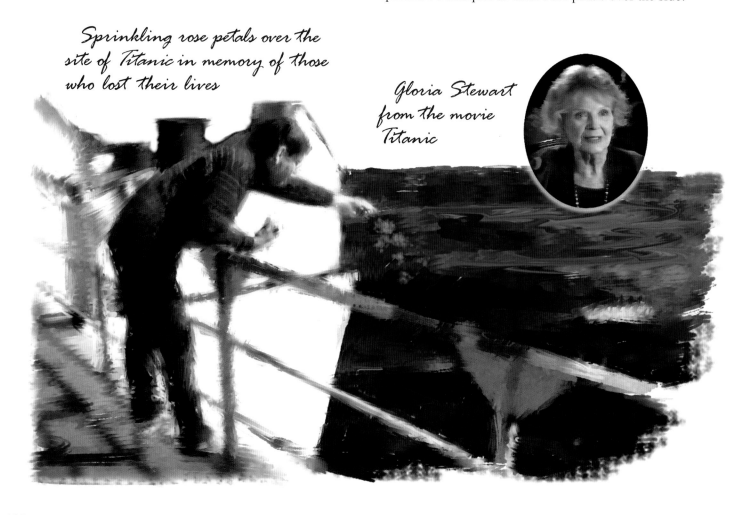

Sprinkling rose petals over the site of Titanic in memory of those who lost their lives

Gloria Stewart from the movie Titanic

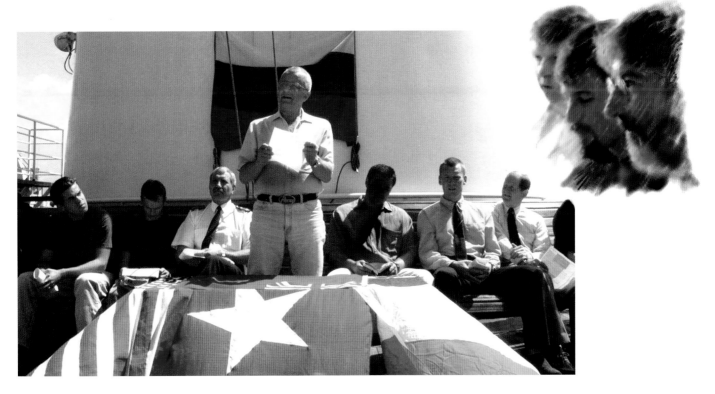

We are all connected.

Violinist Wallace Hartley and members of his ensemble played lively tunes as *Titanic* was sinking and lifeboats were being loaded. He remained at his post instead of getting into a lifeboat. The other two musicians playing with him followed his lead, choosing to stay on deck and continue playing their instruments to entertain and calm the passengers. As the bow sank lower and lower, the group played one last song before being washed overboard into the icy waters. That song was "Nearer My God to Thee."

Two weeks later Hartley's body was recovered by the ship *MacKay-Bennett*. He was still wearing his band uniform and strapped to his body was his music box. He was brought back to England and laid to rest in Lancashire, where 40,000 mourners took part in his funeral.

Violinist Wallace Hartley

There is some dispute whether "Nearer My God to Thee" or "Songe d'Automne" was actually the last song played on board the *Titanic*, but "Nearer My God to Thee" is certainly the sentimental favorite.

It was Sunday morning and our expedition was at an end. We would soon be heading back to St. John's. Denis Cochrane, the English-

man who lives and breathes *Titanic*, came by my cabin and asked if Lowell and I would like to participate in the service. In his hand he had a few copies of "Nearer My God to Thee." During the service four of us took the music and sang. Knowing this was the music played at the same location in the ocean by the three heroic musicians as *Titanic* sank was a touching experience and, as it had been for the musicians, the last overpowering experience before my journey's end. The lyrics just stuck in my throat and I struggled to get them out. Somehow we managed to get through it.

The solemn service on the ship was attended by adherents of many faiths, including Christian, Jewish, Muslim, and Bahá'i.

Singing "Nearer My God to Thee" where it was sung so many years ago

Titanic at Titanic

Artists have painted the *Titanic* many times, but when I was on the *Keldysh*, I wondered how many paintings had ever been done at the exact location where *Titanic* actually sank. I knew of none nor had ever heard of any artist painting at this site, so during the day while the submersibles were on the bottom looking for artifacts, I found a small corner of the ship with a desk and took time to paint a few pictures of the bow.

A few days earlier on my dive, Ralph White had been using his commemorative stamp for envelopes he had brought along to the *Titanic*. At that time Ralph had stamped several special things I wanted to remember as being down at the *Titanic*.

After finishing this painting of the bow, I asked Ralph if he would stamp it. Ralph, Anatoly, and I all signed the stamped painting, and to my knowledge this is the first time a painting has ever been made over where the *Titanic* rests.

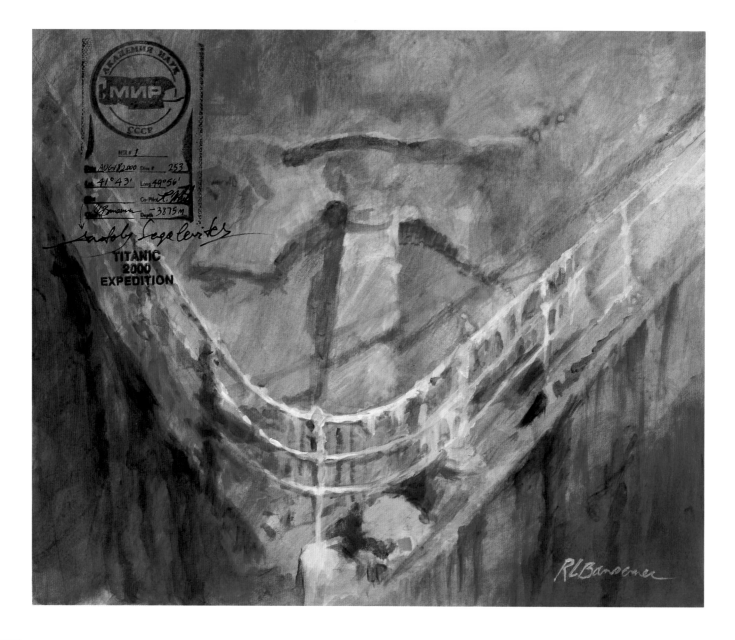

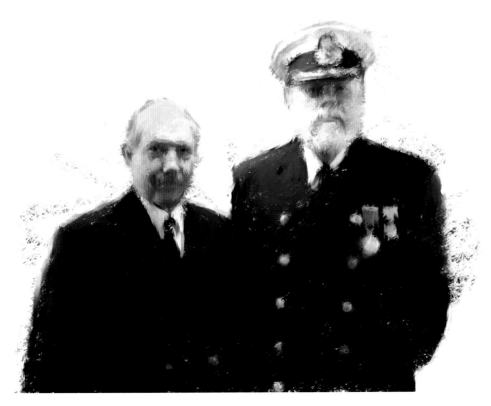

the bow. As Lowell was standing there, the captain looked up over the top of his glasses. I could just read his mind. It was saying, "What on earth am I doing out here with all these crazy Americans?"

It was a priceless look and I just happened to capture it on film. It said a lot about how the Russians and the Americans think differently.

At the same time, I think, Captain Yuri knew how important *Titanic* is to the world and how his ship now has a part in its history. For that reason he not only agreed to have the pictures taken but put on his finest pressed uniform for the occasion.

Would the real captain please stand up.

Lowell often plays the part of *Titanic*'s Captain Smith at special *Titanic* events. Very stately and large, he looks the part and has the voice for it as well. The uniform he wears is a reproduction of the original right down to the insignia on the hat.

For future publicity purposes, Lowell wanted to get some photos of himself alongside the captain of the *Keldysh* while we were still at sea. Lowell made the arrangements and I followed him to the captain's office.

Captain Yuri Gorbach was a very formal kind of man, not someone you would kid around with if you saw him on deck. His job running this, the largest research vessel in the world, commanded dignity and respect from all on board.

He greeted us as we arrived at his quarters, but I sensed his time was valuable. As he and Lowell stood side by side I snapped away with my camera. Then the captain sat down behind his desk while I continued to take more pictures of Lowell looking out through the window towards

Captain Gorbach with Lowell playing the part of Captain Smith

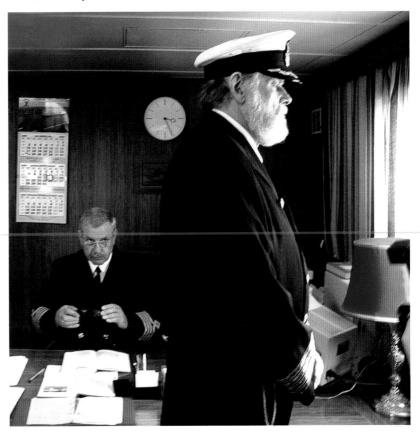

All things must pass.

To end the expedition, the ship's company and crew spent the afternoon enjoying themselves with a cookout and party. I'm not much of a party person but like being an observer, and it was interesting seeing for the first time the Russians and Americans getting together as a whole group just for the purpose of socializing.

By now we had all become familiar with each other's faces when moving about the ship, but today was a little different. All work had been suspended, and no one was busy staying on a schedule to get some necessary job done. This afternoon was simply for a party uniting everyone on board to celebrate the success of the dives. It was finally time for everyone to relax. We all got to know each other a little better.

Some of the people in authority were afraid it might get a little crazy as the party progressed later on in the afternoon, so we were told at the outset we weren't to take pictures after the party got going. I'm assuming no one wanted photos that might be less

An on-deck barbecue

than flattering due to the influence of Russian vodka to appear at some later date. I believe nothing out of the ordinary took place, but after having gotten my fill of the barbecue and leaving the vodka to the others, I couldn't stay awake for all the activities. Eating too much has a way of putting me to sleep. That along with the gentle rolling of the ship seduced me into retiring to my cabin. There in my comfortable bunk I quietly enjoyed feeling the breeze come through the open porthole as I listened to the waves lapping up against the side of the ship. It was a great way for me to end the afternoon.

I thought of how different my experiences of the *Titanic* had been compared to those actually on the ship the night it sank. Some must have been lying in their beds just as I was. Others were on deck perhaps enjoying a party atmosphere like the one above me, at least before the reality of what was happening became clear.

I was thinking how the majestic *Titanic* disappeared from the surface of the earth forever at this spot that now looks no different from any other blue speck in the ocean. The breaking waves make no distinction of what has gone before. Now all remnants of the huge ship—except of course those brought up by the submersibles—were quietly resting miles below me in absolute darkness and quiet. As I lay in my bunk, many thoughts went through my mind of all I had seen in the last few days.

Wallflowers

Two memorable characters, Dr. Barbara Medlin and Denis Cochrane, dancing at the party. Barbara was one of the friendliest and most kind-hearted people on board.

I found it hard to think about dancing and having a party at such a special place where so many people had lost their lives. But many of the people now on the *Keldysh* had been at sea for a full six weeks, so festivities and a celebration of the expedition were in order.

Every other day had been taken up with seriousness as artifacts came to the surface revealing the lives and stories of the people who suffered so frighteningly the night *Titanic* sank. These artifacts would allow future generations to be able to see what *Titanic* was really like. And our voyage had been a safe one.

What better reason could there be to celebrate? We would all leave here knowing we had been a part of history and forever be connected to it. Our leaving would be a sad and joyous occasion. Most of us knew we would likely never be back here again. It was a once-in-a-lifetime experience, and my friend Lowell and I were lucky to have been able to participate.

Visiting the *Titanic* will remain etched in my memory forever, as will the people who became my friends on board the *Keldysh*.

Denis was the staunch Englishman, but he cut loose at the party.

The thoughts of leaving

Sometimes when I leave home, even on short trips, it crosses my mind it might be my last trip, that some calamity might happen along the way and I will never come home. I suppose everyone has these same thoughts. Of course, something could happen on the way to the grocery store, but for some reason the thought occurs more often when travelling afar. As exciting as it is to leave home, it means departing from what is comfortable and secure. When I'd left home this time, for the long and risky voyage to *Titanic*, I'd had the same feeling, and added to it was the knowledge that I was going to the place where life *did* end for more than fifteen hundred people.

After being somewhere for even a short time, another feeling of sadness comes over me: knowing I'm going to miss it when I leave. In some ways it's harder than leaving home since I know I may never pass this way again. In the future I'll look back on this trip with images I've captured on film and canvas and remember the experiences. I'm certain they will not fade from my memory. Sharing my feelings about the dive to *Titanic* has been difficult, not because I wasn't willing but because they were on so many levels and thus hard to express.

Being the 112th person to have ever seen the *Titanic* in its resting place under water left me with a bit of a burden, especially since so many others might have more appropriately taken my place. Sometimes good things just come around, and I'm not sure why. This journey was a gift and a pleasant surprise, a release from the usual demands that take up most of our daily lives. I'll take and appreciate the good things whenever they come my way and deal with the others in what I hope is the same good spirit. I am thankful to those who made my trip such a rich experience. It was a time for making new friends with diverse and colorful personalities.

I will always vividly remember the moments I spent on the ocean floor visiting the place from which so many souls had gone on and seeing what they have left behind to remember them by. It also turned out to be a time for remembering my own loved ones in a very profound way.

The *Keldysh* quietly and without fanfare set its heading to Newfoundland and charted its course away from this most remarkable place on the ocean. I watched from the bridge as we began to move away from the past and all that's hidden there. I doubt that another opportunity to visit the *Titanic* will come again, but should it ever, I'll joyfully accept it. In the meantime, I hope this journal will be a sufficient record of my experience.

Roger Bansemer

If you enjoyed reading this book, here are some other Pineapple Press titles you might enjoy as well. To request our complete catalog or to place an order, write to Pineapple Press, P.O. Box 3889, Sarasota, Florida 34230, or call 1-800-PINEAPL (746-3275). Or visit our website at www.pineapplepress.com.

Bansemer's Book of the Southern Shores by Roger Bansemer. This is an artist's journal, describing in words and images the colorful places nestled up and down these coasts as he strolls through the towns, guides his boat along the white beaches, and chats with the locals. ISBN 1-56164-294-0 (hb)

Bansemer's Book of Florida Lighthouses by Roger Bansemer. This beautiful book depicts Florida's 30 lighthouses in over 200 paintings and sketches. Engaging text, historical tidbits, and charming sketches accompany full-color paintings. ISBN 1-56164-172-3 (hb)

Bansemer's Book of Carolina and Georgia Lighthouses by Roger Bansemer. Written and illustrated in the same engaging style as Bansemer's Florida book, this volume accurately portrays how each lighthouse along the coasts of the Carolinas and Georgia looks today. ISBN 1-56164-194-4 (hb)

Florida Lighthouse Trail edited by Thomas Taylor. A collection of the histories of Florida's light stations by different authors, each an authority on a particular lighthouse. Chock-full of information on dates of construction and operation, foundation materials, lighting equipment, and more. Includes names, addresses, phone numbers, e-mail addresses, and websites for lighthouse organizations, plus complete directions to each lighthouse. ISBN 1-56164-203-7 (pb)

Guide to Florida Lighthouses Second Edition by Elinor De Wire. Its lighthouses are some of Florida's oldest and most historic structures, with diverse styles of architecture and daymark designs. Revised with new photos of renovated lighthouses, plus discussions of four lighthouses not included in the first edition. ISBN 0-910923-74-4 (pb)

Guardians of the Lights by Elinor De Wire. Stories of the men and women of the U.S. Lighthouse Service. In a charming blend of history and human interest, this book paints a colorful portrait of the lives of a vanished breed. ISBN 1-56164-077-8 (hb); 1-56164-119-7 (pb)

Georgia's Lighthouses and Historic Coastal Sites by Kevin M. McCarthy. With full-color paintings by maritime artist William L. Trotter, this book retraces the history of 30 sites in the Peach State. ISBN 1-56164-143-X (pb)

Haunted Lighthouses and How to Find Them by George Steitz. The producer of the popular television series *Haunted Lighthouses* takes you on a tour of these bewitching monuments as he films. ISBN 1-56164-268-1 (pb)

Key Biscayne: A History of Miami's Tropical Island and the Cape Florida Lighthouse by Joan Gill Blank. This is the engaging history of the southernmost barrier island in the United States and the Cape Florida Lighthouse, which has stood at Key Biscayne's southern tip for 170 years. ISBN 1-56164-096-4 (hb); 1-56164-103-0 (pb)

Lighthouses of the Florida Keys by Love Dean. Intriguing, well-researched accounts of the shipwrecks, construction mishaps, natural disasters, and Indian attacks that plagued the Florida Keys' lighthouses and their keepers. ISBN 1-56164-160-X (hb); 1-56164-165-0 (pb)

Lighthouses of the Carolinas by Terrance Zepke. Eighteen lighthouses aid mariners traveling the coasts of North and South Carolina. Here is the story of each, from origin to current status, along with visiting information and photographs. Newly revised to include up-to-date information on the long-awaited and much-debated Cape Hatteras Lighthouse move, plus websites for area visitors' centers and tourist bureaus. ISBN 1-56164-148-0 (pb)

Lighthouses of Ireland by Kevin M. McCarthy with paintings by William L. Trotter. Eighty navigational aids under the authority of the Commissioners of Irish Lights dot the 2,000 miles of Irish coastline. Each is addressed here, and 30 of the most interesting ones are featured with detailed histories and full-color paintings. ISBN 1-56164-131-6 (hb)

The Florida Keys Volume 1: *A History of the Pioneers* by John Viele. As vividly portrayed as if they were characters in a novel, the true-life inhabitants of the Florida Keys will capture your admiration as you share in the dreams and realities of their daily lives. ISBN 1-56164-101-4 (hb)